THE ART OF
5THCELL™

presented by

UDON ENTERTAINMENT

THE ART OF **5TH**CELL ™

FOREWORD

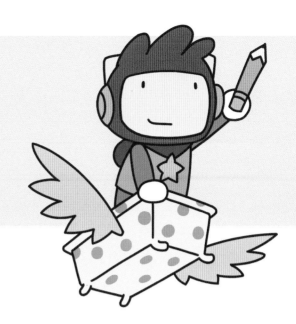

We started 5TH Cell in late 2003 with the goal of creating beautiful and engaging worlds, filled with memorable characters, and supported by innovative gameplay. Eleven years later, we've had our share of success and failure, but that desire hasn't changed. We choose the game industry because of the impact our products can have on the generations. The ability to craft a world, and invite the player to participate, is unique to our medium.

Similar to our approach to game design, our art aims to uniquely refresh and engage the player. We set out to tell a story in the hearts and minds of our audience and use the visuals of the game to enhance that experience. Beginning with an initial narrative vision, we put pen to paper and then draw and draw until the art is a perfect fit for the world we are creating.

There are many factors we consider in this process. Everything from function, to backstory and history, to emotional feel and tone are critical to the success of a piece of art. We know it is finished when the player can see where the art fits in the world, with each element telling a unique and compelling piece of the larger story.

Over the years we've had the pleasure of working with amazing talent across all disciplines. A vision is just that, the starting point for a product. It takes the rest of the team to execute on that vision. Every project hits a dark place once the initial thrill of the concept wears off, and before you're able to sit down and enjoy playing the game. When that happens, you need to believe, because that's all you have. We have a team of people that believe, who come to work every day ready to embrace the unique challenges you face when crafting original worlds.

To all our fans, we hope you enjoy a peak into the process that goes into crafting the worlds we've shared with you. We wouldn't make games unless we believed they would reach and impact the audience they're intended for. Although it's awesome to look back and reflect on where we've been, our focus is on the upcoming original projects we have in the works at 5TH Cell. We can't wait to share them with you in the coming years.

Best,
JEREMIAH, JOE & MARIUS

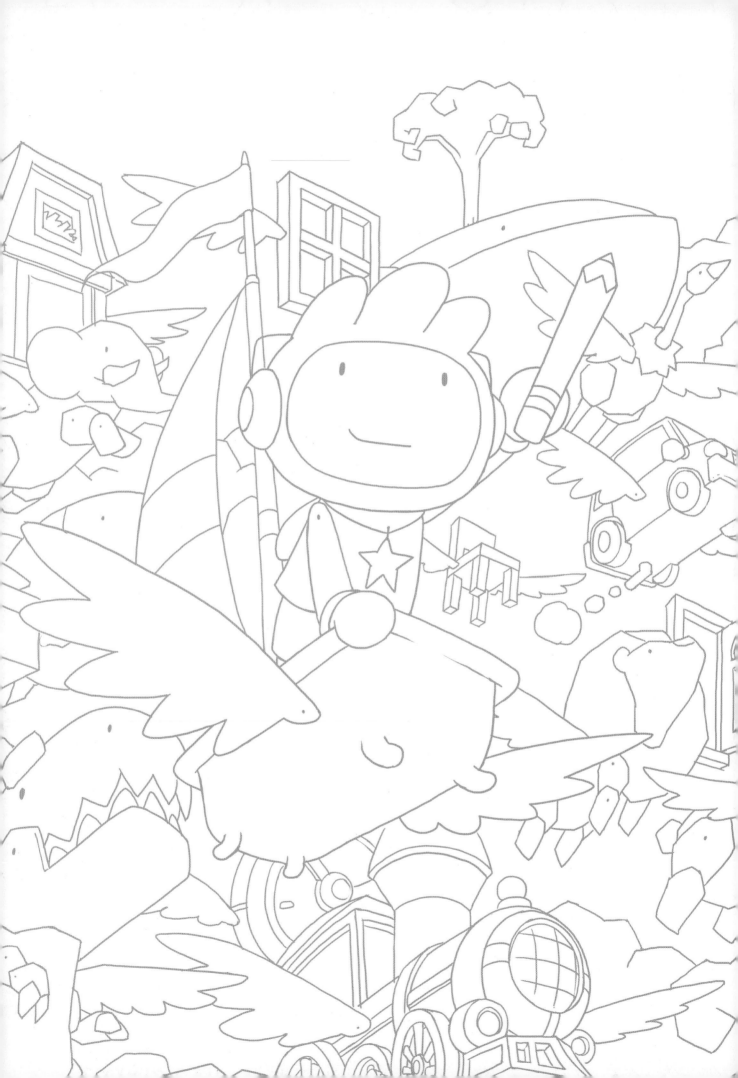

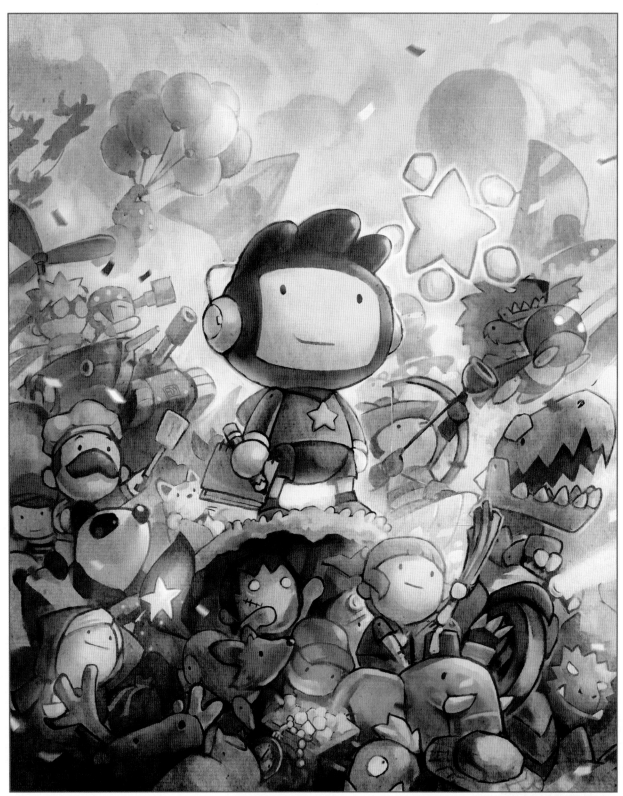

● SCRIBBLENAUTS - NINTENDO POWER MAGAZINE COVER

COMMENT

Amongst all the promotional artwork I've done for *Scribblenauts*, these Nintendo Power covers were my favorite. I was given a lot of freedom to encapsulate what *Scribblenauts* was about. Much like the game itself, coming up with the objects and how they interacted was very challenging. Although for my purpose, it's a very visual one. I first took into consideration the kinds of objects based on size and shapes, then their individual appeal and what they were doing, and finally how their color contributed to the overall composition. I wanted to get a good variety of everything, mainly characters and creatures as they were my favorites, and what connected with the fans the most. *[Edison Yan]*

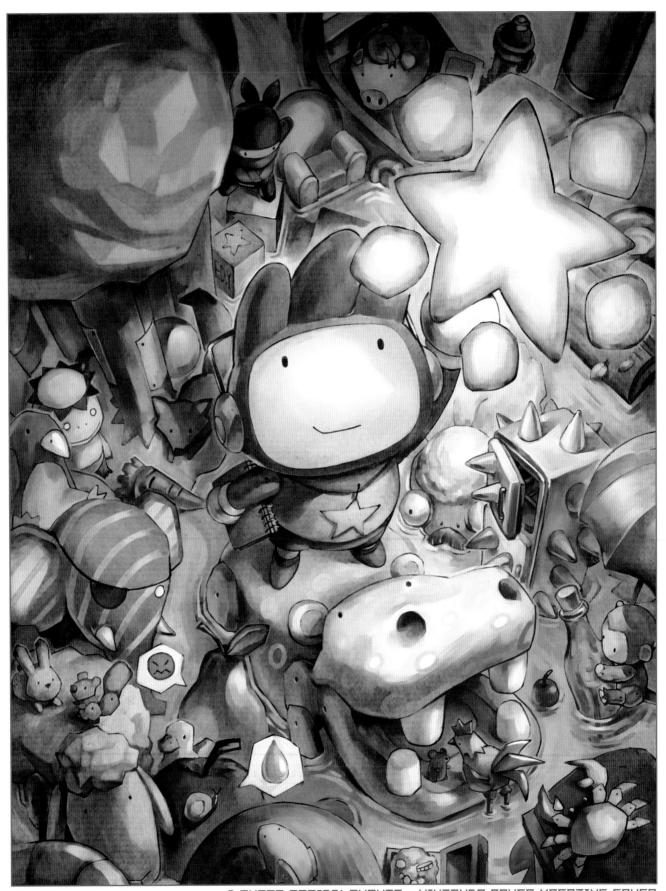

● SUPER SCRIBBLENAUTS - NINTENDO POWER MAGAZINE COVER

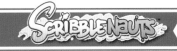

● SUPER SCRIBBLENAUTS - NINTENDO POWER MAGAZINE COVER

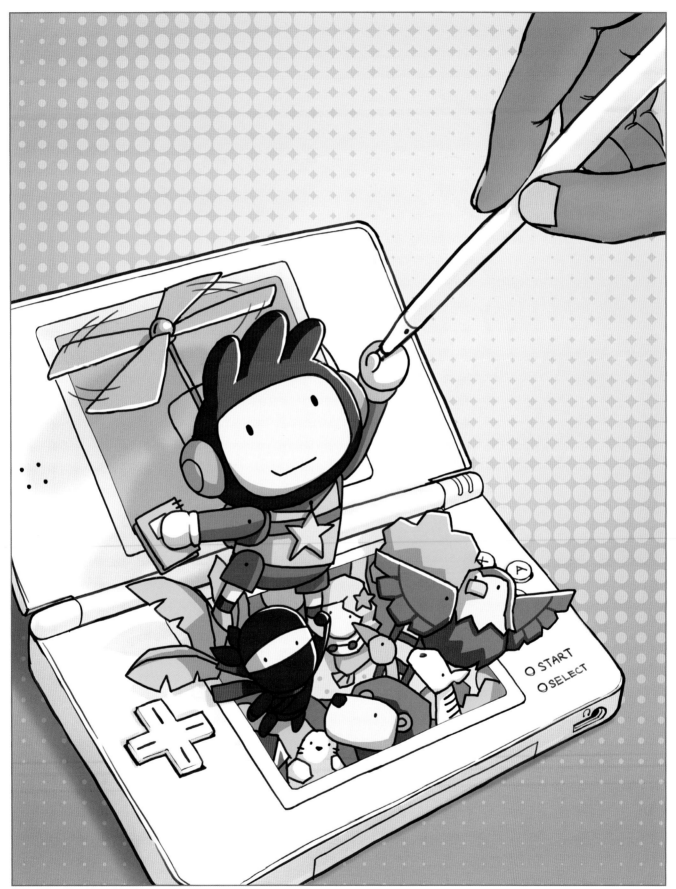

● SCRIBBLENAUTS - PROMOTIONAL ARTWORK

● SCRIBBLENAUTS - PROMOTIONAL ARTWORK

THE ART OF 5THCELL™

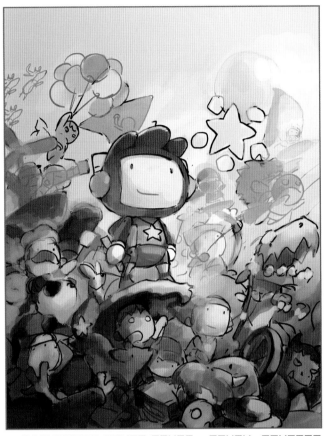

● NINTENDO POWER COVER - ROUGH CONCEPT

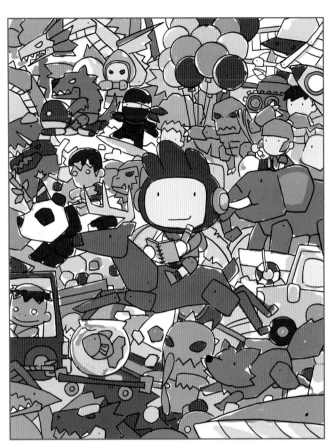

● PROMO ART - ROUGH CONCEPT

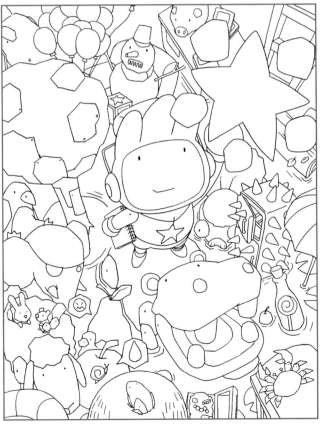

● NINTENDO POWER COVER - LINE ART

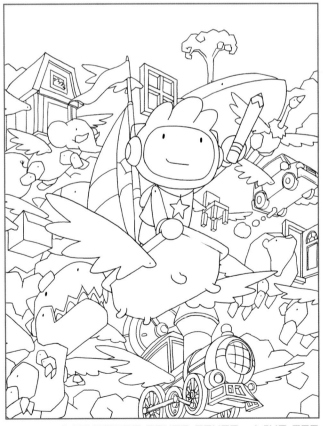

● NINTENDO POWER COVER - LINE ART

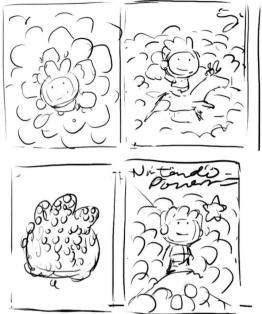

● MAGAZINE COVER - EARLY SKETCHES

◇ COMMENT

This was a concept for the button contest at PAX, where the winner would win a custom Nintendo DSi. *[Edison Yan]*

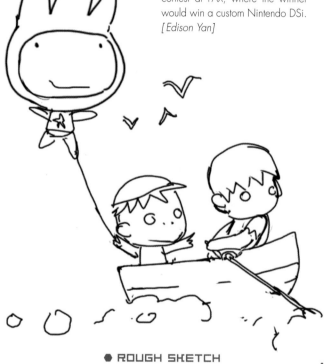

● ROUGH SKETCH

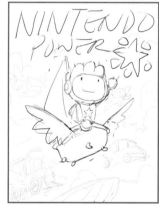

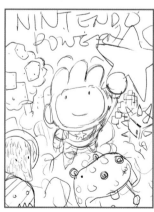 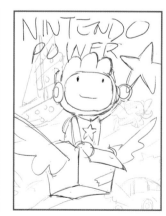 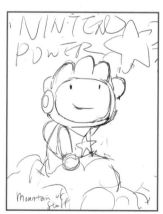

● MAGAZINE COVER - ROUGH SKETCHES

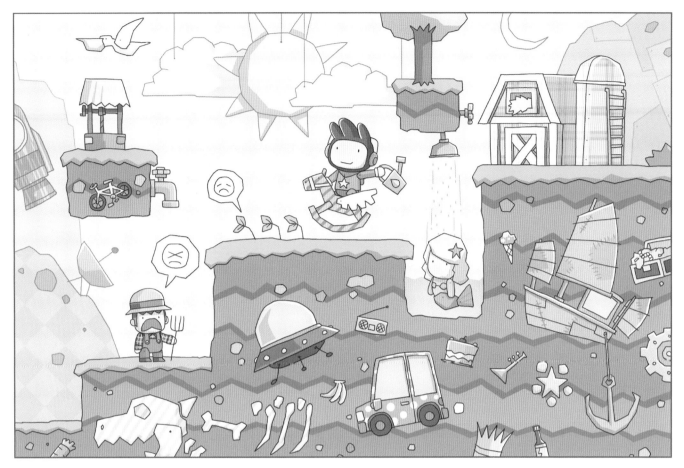

● SUPER SCRIBBLENAUTS - NINTENDO POWER MAGAZINE INSERT

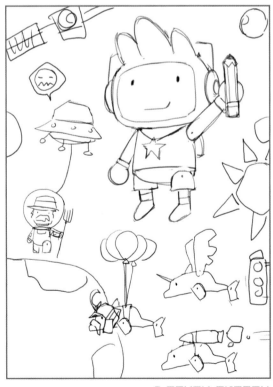

● ROUGH SKETCH

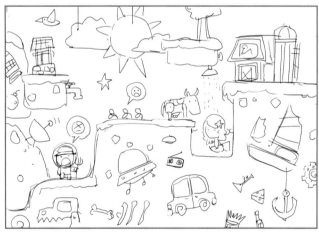

● ROUGH SKETCH

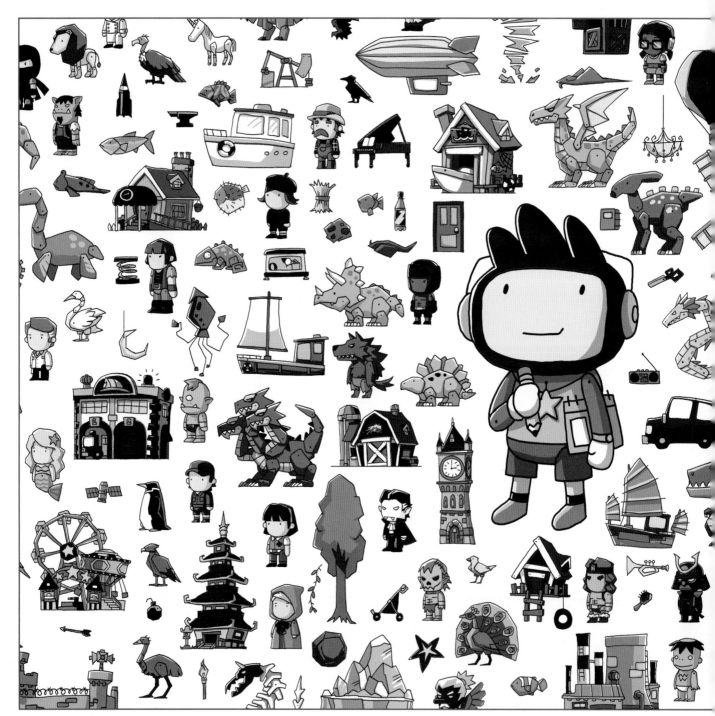

● SCRIBBLENAUTS - PROMOTIONAL ARTWORK

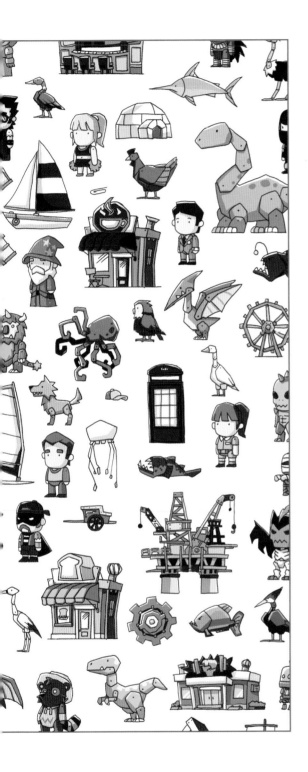

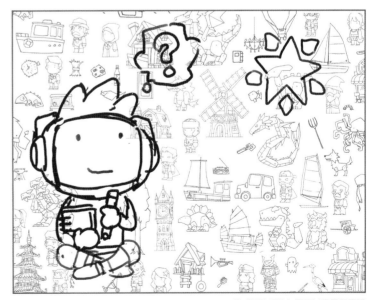

● ROUGH CONCEPTS

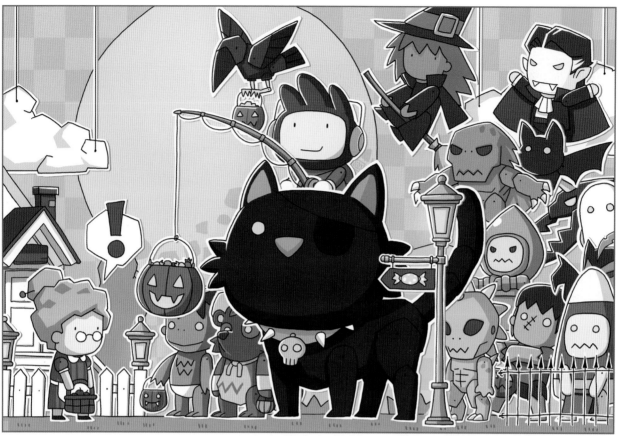

● SCRIBBLENAUTS - HALLOWEEN PROMOTIONAL IMAGE

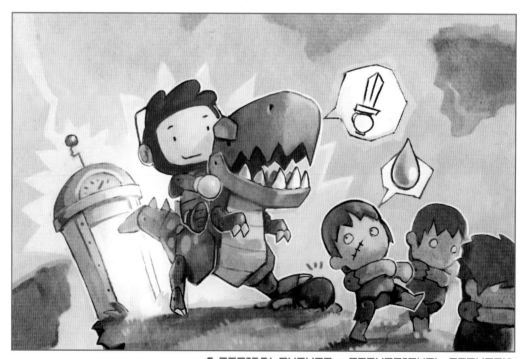

● SCRIBBLENAUTS - PROMOTIONAL ARTWORK

◇ COMMENT

During E3 2009, a member of the popular game forum Neogaf had a mind-blowing experience with *Scribblenauts*, riding a dinosaur and travelling back in time. This image was later drawn to show what he wrote, which became known as "Post 217". *[Joe Tringali]*

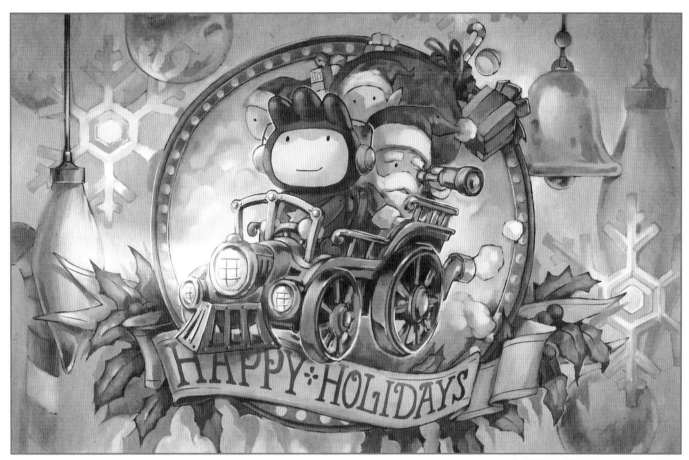

● 2009 CHRISTMAS CARD

COMMENT

The promotional drawings are very near and dear to me because I was given a lot of freedom with them. The 2009 one, featured Maxwell and Santa on this train-car/loco-car. This piqued the fan's interest as to whether or not it was in the game... and sure enough, it made it in! [Edison Yan]

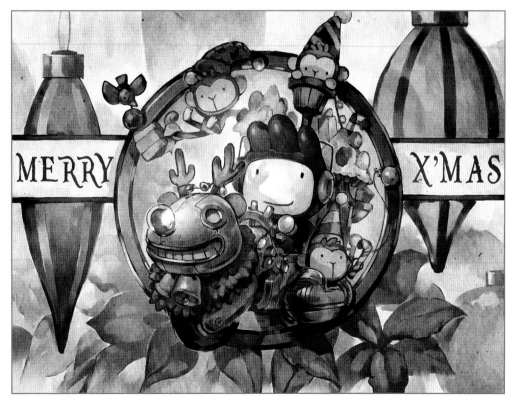

● 2010 CHRISTMAS CARD

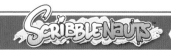

STARITE

MAXWELL

SCRIBBLENAUTS

● SCRIBBLENAUTS - GAME DEVELOPER MAGAZINE COVER

● SCRIBBLENAUTS - GAME DEVELOPER MAGAZINE COVER ALTERNATES

● SCRIBBLENAUTS - GAME BOX ART

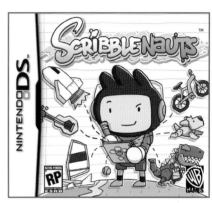

● GAME BOX ART
WITH GRAPHICS

⬡ COMMENT

We wanted the packaging for *Scribblenauts* to capture the imagination aspect of the game. We originally had Maxwell positioned in front of a bunch of objects, but felt it didn't demonstrate enough action, so we changed it to him writing, and the objects coming from the notebook. *[Joe Tringali]*

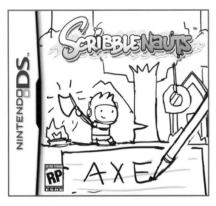

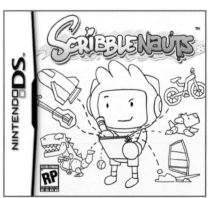

● ROUGH CONCEPTS

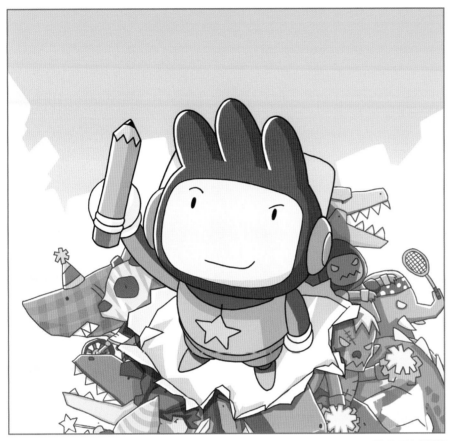

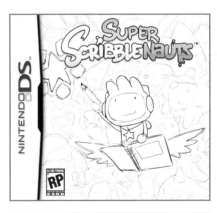

● GAME BOX ART
 WITH GRAPHICS

● SUPER SCRIBBLENAUTS - GAME BOX ART

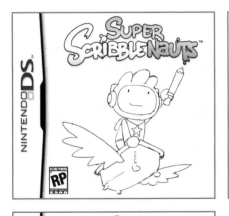

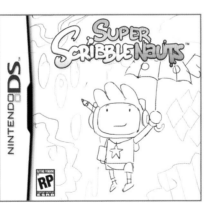

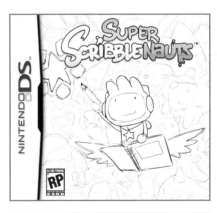

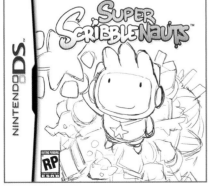

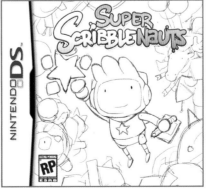

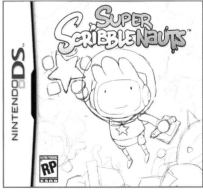

● ROUGH CONCEPTS

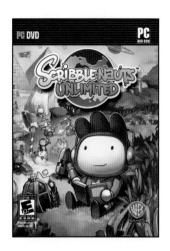

● GAME BOXES WITH
GRAPHICS

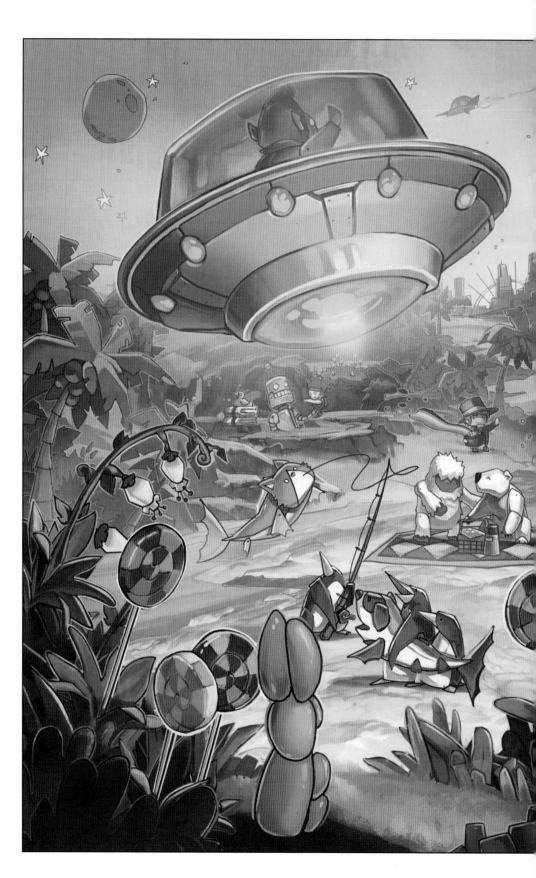

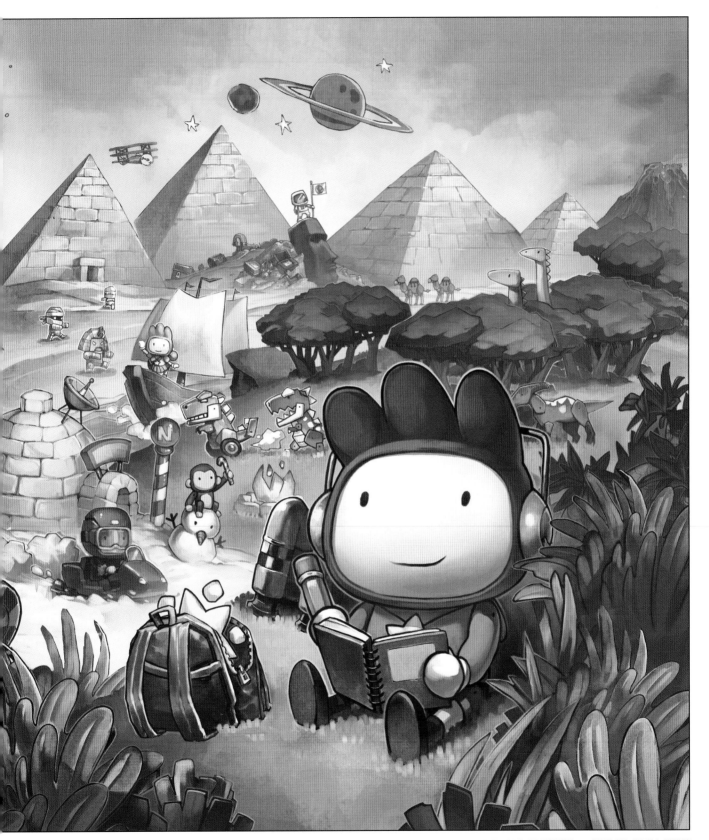

● SCRIBBLENAUTS UNLIMITED - GAME BOX ART

◆ MAXWELL

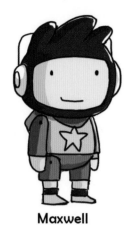

Maxwell

◆ CHARACTER DESIGN

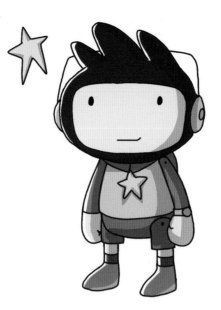

◆ SCRIBBLENAUTS

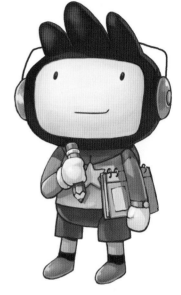

◆ SUPER SCRIBBLENAUTS

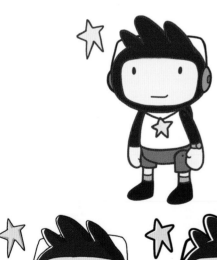

◆ EARLY STYLE VARIATIONS

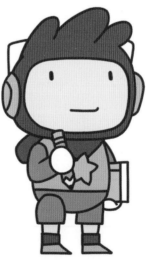

◆ SCRIBBLENAUTS
UNLIMITED

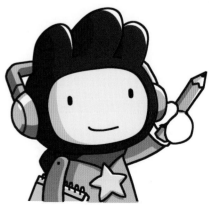

◆ SCRIBBLENAUTS REMIX

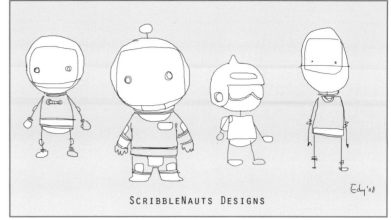

SCRIBBLENAUTS DESIGNS

● ROUGH CONCEPTS

COMMENT

Maxwell initially was an astro"naut", but we felt that the appeal wasn't quite there. So we gave him a face and made him more human-like. [Edison Yan]

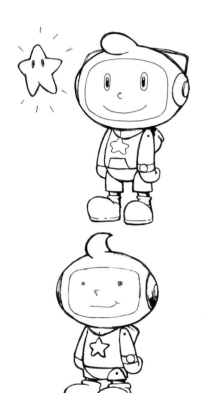

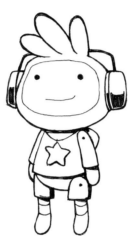

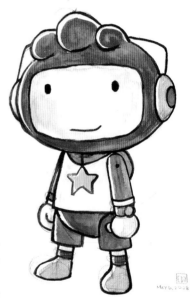

COMMENT

It took about three months to finalize the concept for Maxwell, the main character in Scribblenauts. [Joe Tringali]

We couldn't decide whether to give him hair or have him wear a helmet. It was actually Jeremiah's idea to give him three hair bits on top of his head. [Edison Yan]

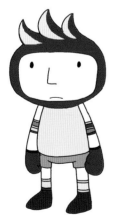

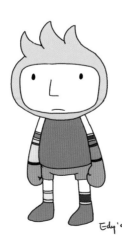

● ROUGH CONCEPTS

● PEOPLE

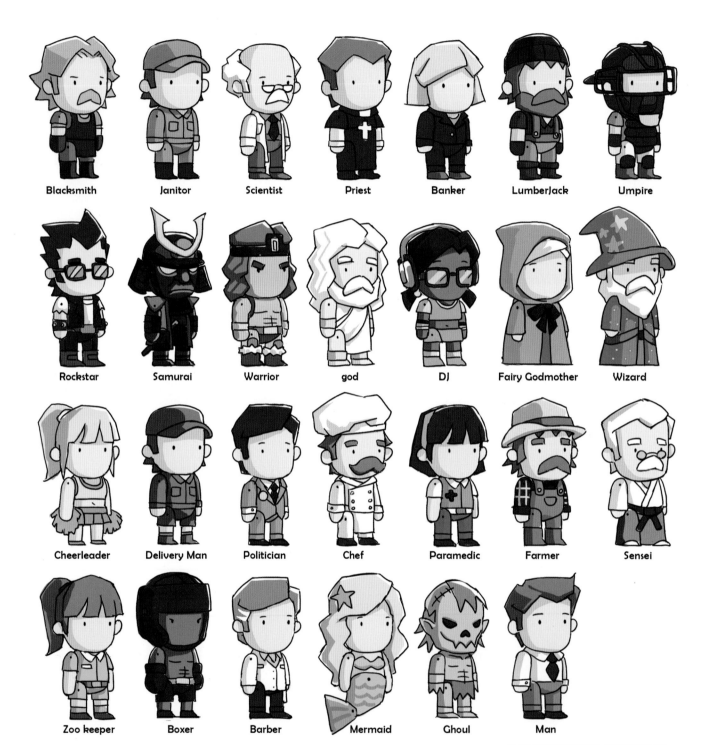

Blacksmith · Janitor · Scientist · Priest · Banker · LumberJack · Umpire

Rockstar · Samurai · Warrior · god · DJ · Fairy Godmother · Wizard

Cheerleader · Delivery Man · Politician · Chef · Paramedic · Farmer · Sensei

Zoo keeper · Boxer · Barber · Mermaid · Ghoul · Man

● CHARACTER DESIGNS

◇ COMMENT

Due to the extensive number of humanoids in *Scribblenauts*, we created a single template that would fit each character. This meant we could animate on a single rig, which would work across all humanoids. [*Joe Tringali*]

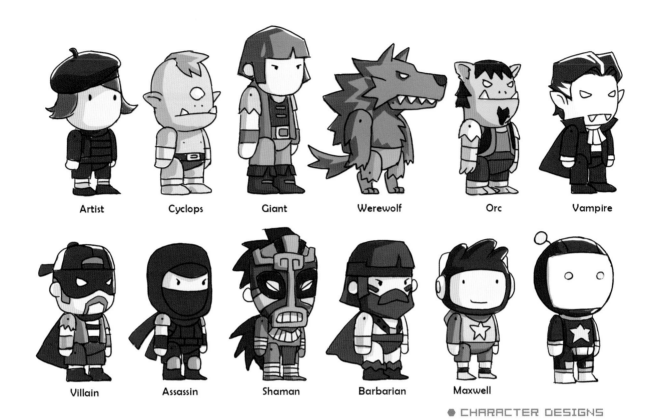

Artist Cyclops Giant Werewolf Orc Vampire

Villain Assassin Shaman Barbarian Maxwell

● CHARACTER DESIGNS

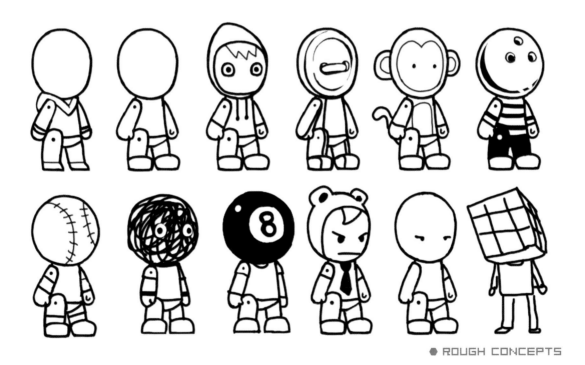

● ROUGH CONCEPTS

Mothman

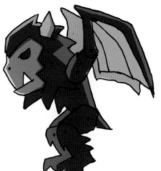

Ahool

Death Worm

Kappa

Tengu

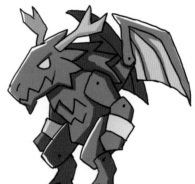

Jersey Devil

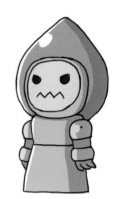

Flatwood's Monster

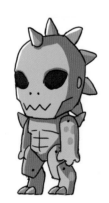

Chupacabra

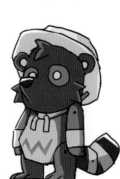

Tanuki

Spring Heeled Jack

Monster

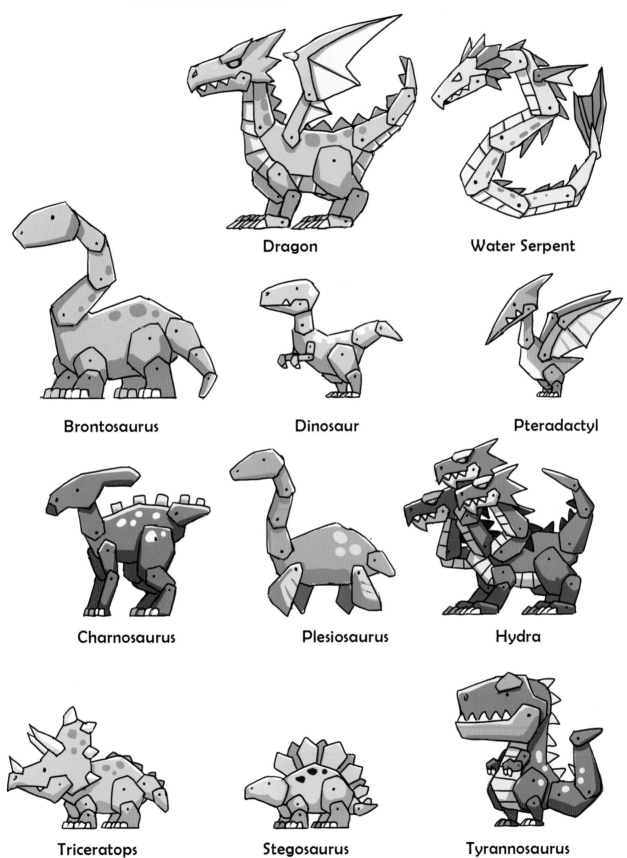

Dragon

Water Serpent

Brontosaurus

Dinosaur

Pteradactyl

Charnosaurus

Plesiosaurus

Hydra

Triceratops

Stegosaurus

Tyrannosaurus

CHARACTER TURNAROUNDS

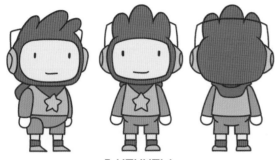

● MAXWELL

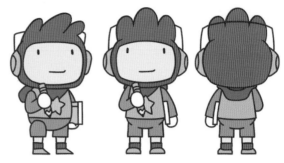

● WITH NOTEPAD

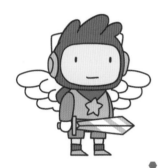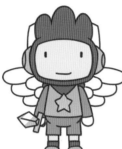

● WITH SWORD/WINGS

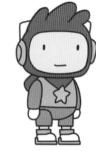

● WITH ROCKET SHOES

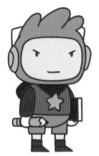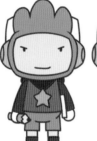

● EVIL MAXWELL

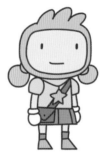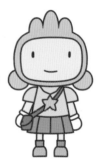

● LILY

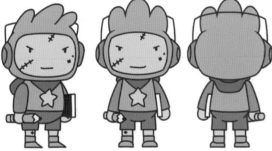

● ZOMBIE MAXWELL

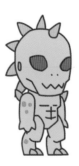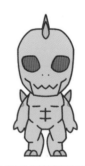

● CHUPACABRA

SIDE
THICKNESS

● STARITE

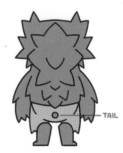

TAIL

● WEREWOLF

THE ART OF **5THCELL**™

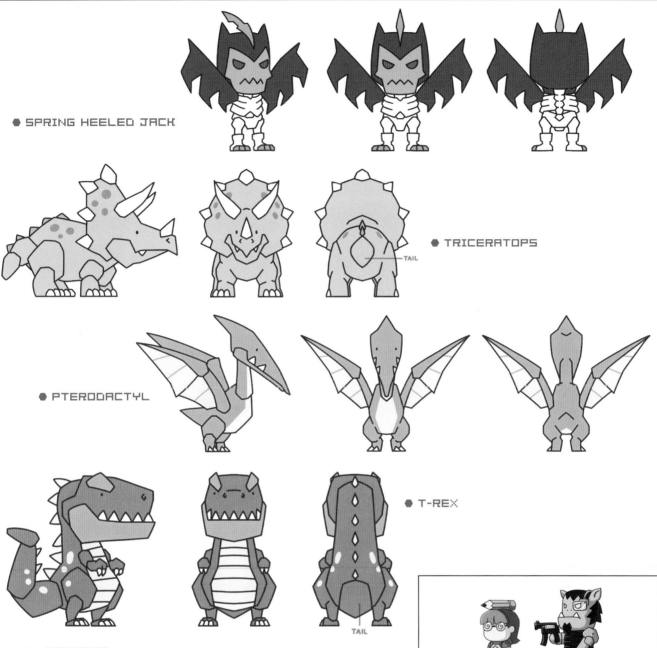

● SPRING HEELED JACK

● TRICERATOPS

TAIL

● PTERODACTYL

● T-REX

TAIL

⬡ COMMENT

T-Rex was my favorite character and ended up being my Avatar, except I added red gloves and a headband to resemble a character from a fighting game. What most people don't know is that "Edison" protects all art-related things, e.g. art galleiries, art books, and museums. *[Edison Yan]*

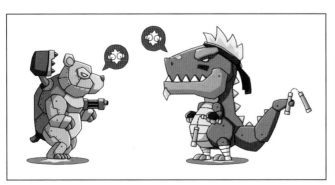

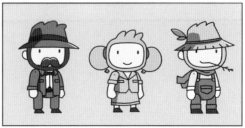

● MISC CHARACTERS

BIRDS/FISH
ROUGH CONCEPTS

Vulture

Owl

Penguin

Duck

Emu

Manta Ray

Sting Ray

Barracuda

Chicken

Osprey

Crow

Bird

Ostrich

Star Fish

Monk Fish

Angler Fish

Clown Fish

Swan

Goose

Peacock

Woodpecker

Piranha

Mudskipper

Sword Fish

MISC OBJECTS
ROUGH CONCEPTS

COMMENT

This was the first set of objects drawn for *Scribblenauts*, we chose a variety of sizes and objects to make sure our style worked. *[Joe Tringali]*

Roller Coaster

Palace

Fort

Canyon

Volcano

Valley

Power Plant

Pit

Cave

Spire

Nuclear Reactor

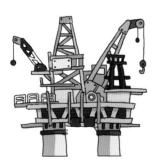

Oil Rig

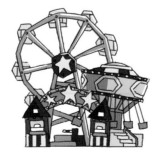

Theme Park

Cliff

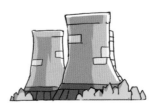

Reactor

Glacier

BUILDINGS/TERRAIN
ROUGH CONCEPTS

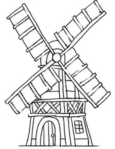

Clock Tower **Bell Tower** **Silo** **Tower** **Wind mill**

COMMENT

Doing buildings was a challenge as it's quite hard to cram detail into a sprite. We wanted to really capture the essence of what makes up some of these buildings, with minimal detail. *[Edison Yan]*

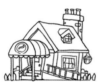
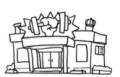
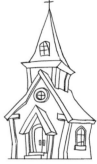

Barn **Boathouse** **Coffee** **Bakery** **Church**

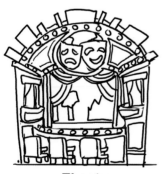

Fire station **Prison** **Nursing Home** **Gym**

Theatre

Boulder / Huge Boulder

Oil Rig **Before** **After**
*looks too wide

Stable

Giant Cog **Silo** **Water Wheel**
*please repeat the same treatment to the Ferris wheel so it's not a perfect circle.

⬡ BACKGROUNDS

 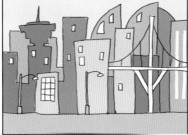 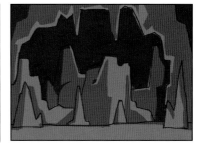

 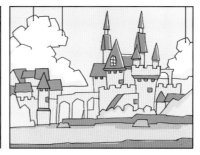

 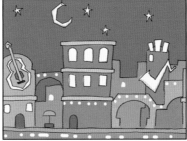

⬡ COMMENT

In order for the characters to stand out, we limited the palette
and complexity of each background. [Edison Yan]

◆ VISUAL STYLE CONCEPTS

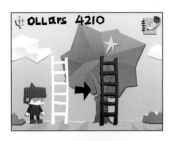

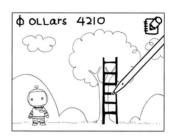
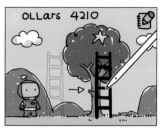
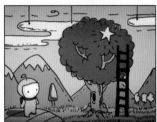
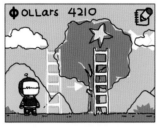
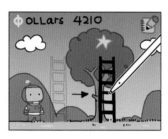
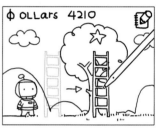
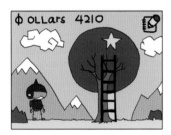
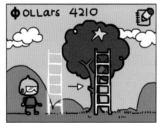
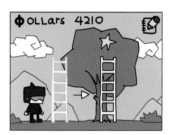
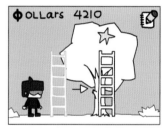

COMMENT

We experimented with various styles for the look of *Scribblenauts*, from very loose kid-like drawings to paper cutouts. *[Edison Yan]*

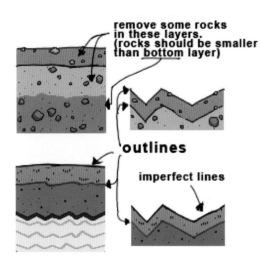

remove some rocks in these layers. (rocks should be smaller than bottom layer)

outlines

imperfect lines

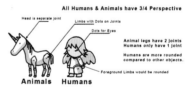

All Humans & Animals have 3/4 Perspective

Head is separate joint
Limbs with Dots on Joints
Dots for Eyes
Animal legs have 2 joints
Humans only have 1 joint
Humans are more rounded compared to other objects.
Foreground Limbs would be rounded

Animals Humans

All Architecture have 3/4 Perspective

Round Objects would have white rimlight

Architecture

Front view.. on most objects.
※when objects don't read as well front or side (ie. hairbrush)

Medium/small objects

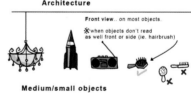

ALL moving vehicles are drawn Side view.
All vehicles Transparent Windows.

Vehicles

Non-living Humanoids have circular eyes. All Humanoids share the same skeletal animation system

All objects have a choppy / uneven look no perfect straight lines other than hanging strings

Wheels are not perfect circles

All Objects have 2 tone Shading. A natural color and a shadow color... some with rimlight

BG FG

Floating objects in the sky have hanging strings

Here is a Palette I've been working with.

ICONS

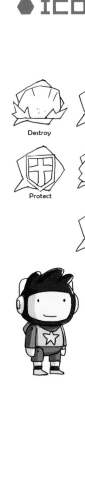

Destroy · Consume · Investigate · Follow

Protect · Use · Scared · Steal

Friendly · Hostile · Sleepy

Sick · Mount

Neutral · Collide

● BEHAVIOR CONCEPTS

● BEHAVIOR CONCEPTS

● STARITE CONCEPTS

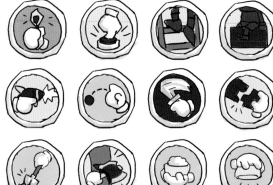
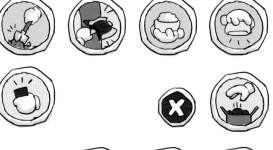

● COMMAND ICON CONCEPTS

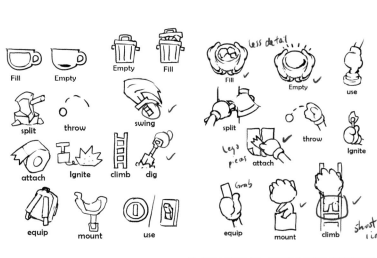

Fill · Empty · Empty · Fill · Fill · Empty · use

split · throw · swing · split · throw · Ignite

attach · Ignite · climb · dig · Legs pieas attach

equip · mount · use · equip · mount · climb · shout i can

Grab · less detail!

● COMMAND ICON CONCEPTS

● PROMOTIONAL ART

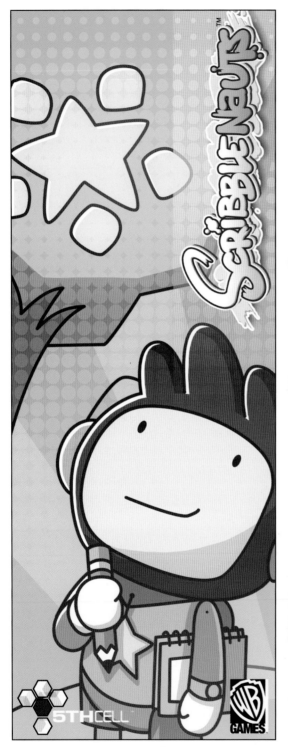

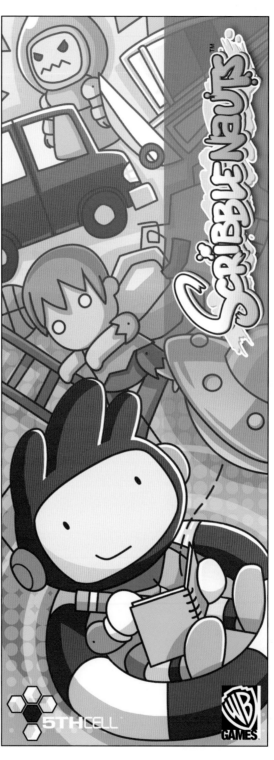

● PENNY ARCADE EXPO 2009

● ROUGH CONCEPTS

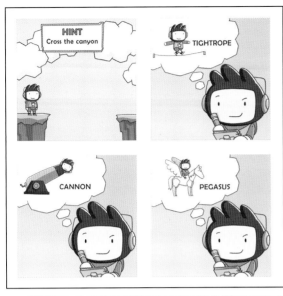

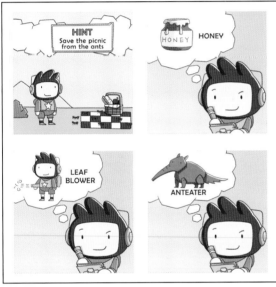

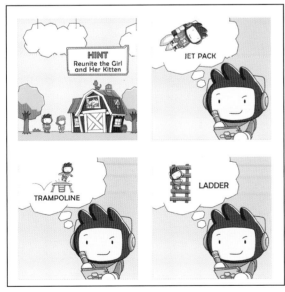

● PROMOTIONAL POSTER COMIC ART

● PROMOTIONAL ART

● HOLIDAY ART

● SCRIBBLENAUTS
UNLIMITED ART

● MAXWELL / LILY

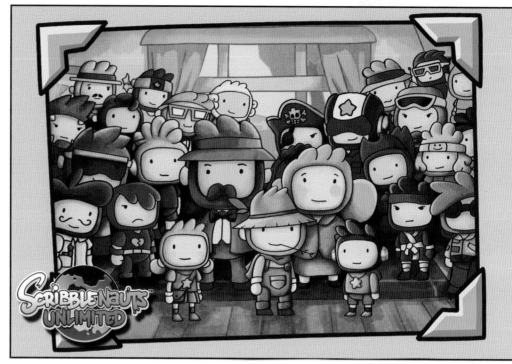

● FAMILY PORTRAIT

● SUPER SCRIBBLENAUTS PROMO ART

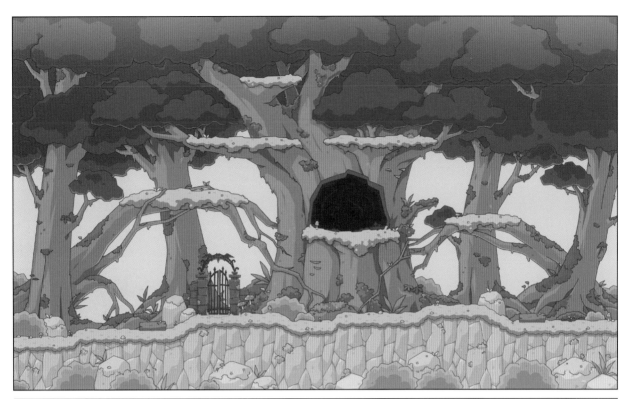

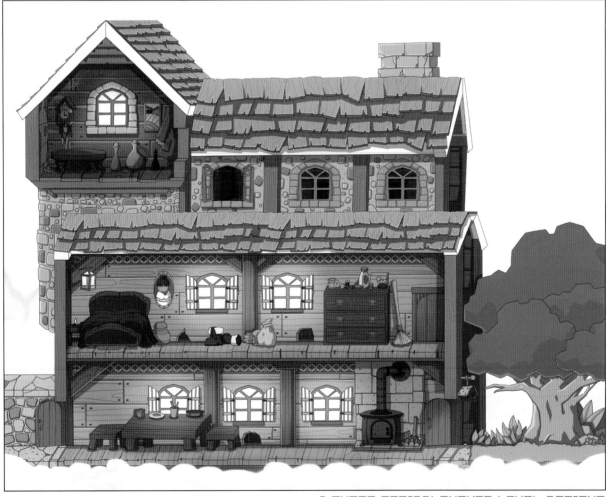

● SUPER SCRIBBLENAUTS LEVEL DESIGNS

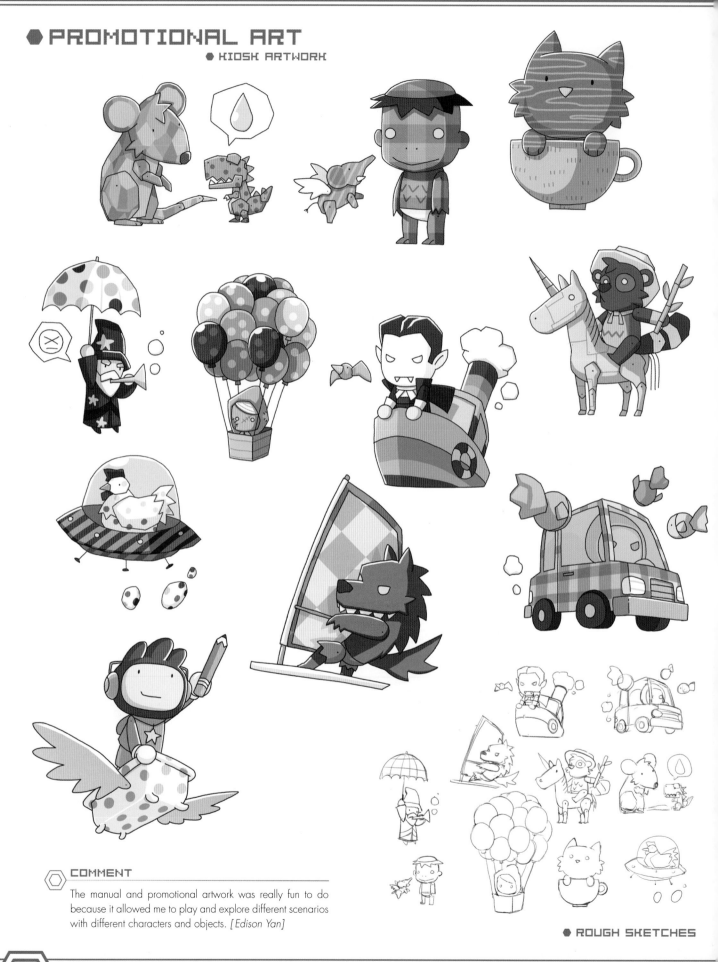

COMMENT

The manual and promotional artwork was really fun to do because it allowed me to play and explore different scenarios with different characters and objects. [Edison Yan]

● ROUGH SKETCHES

MANUAL ARTWORK

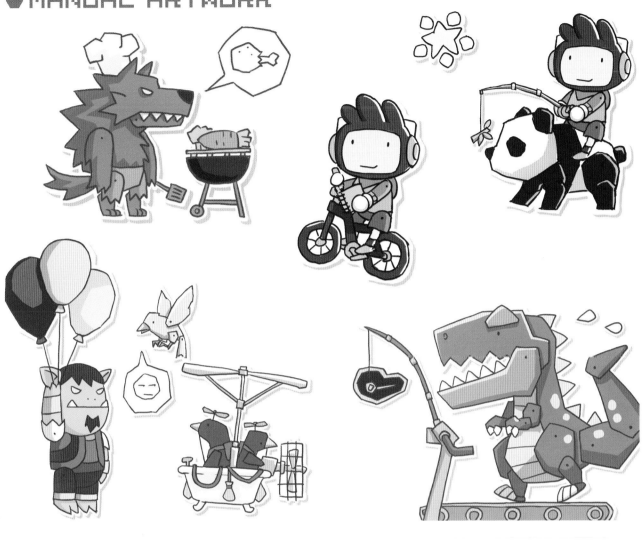

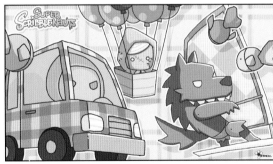

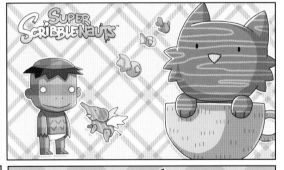

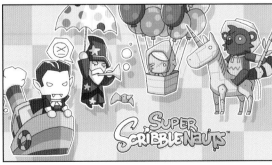

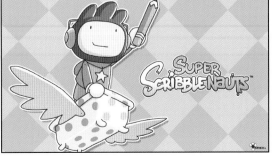

● WALLPAPERS

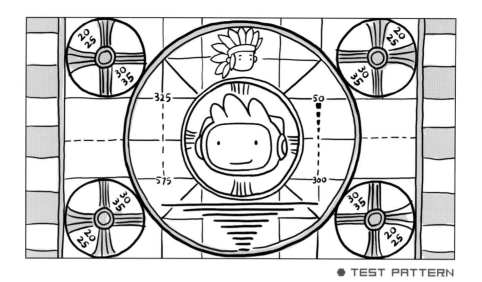

● TEST PATTERN

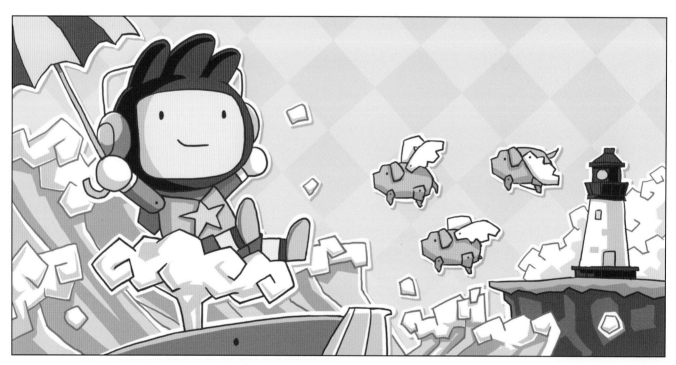

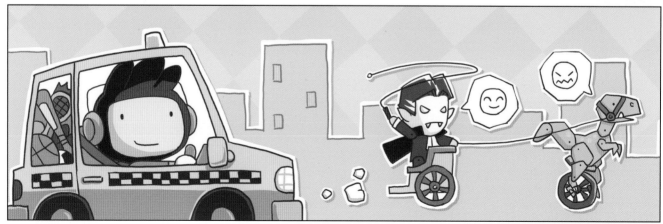

● MANUAL ARTWORK

◆ SCRIBBLENAUTS ENDING CINEMATIC

● LINE ART/ROUGH SKETCHES

 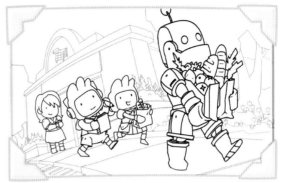

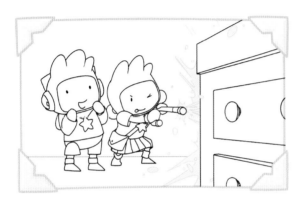 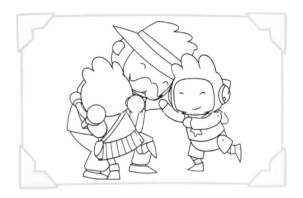

 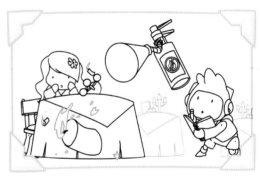

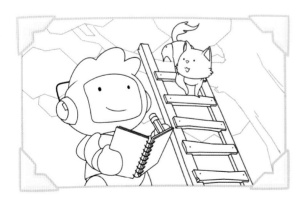

◆ MERCHANDISE

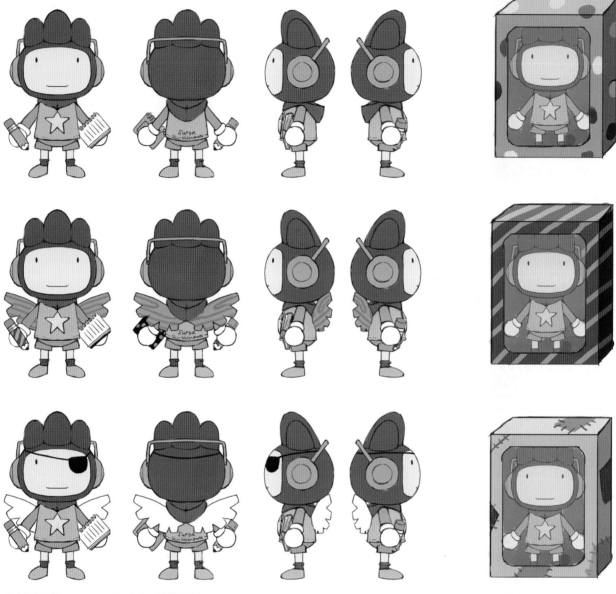

● MAXWELL PLUSHIE DESIGNS

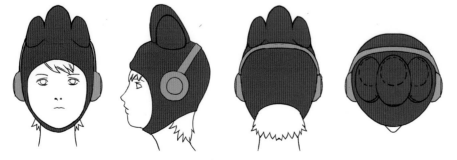

● SCRIBBLENAUTS ROOSTER HAT DESIGN

⬡ COMMENT

We came up with the "Rooster Hat" as a pre-order gift for the original *Scribblenauts*. [Joe Tringali]

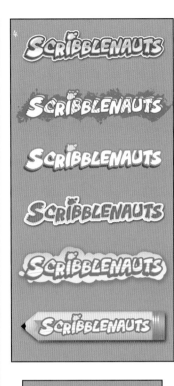

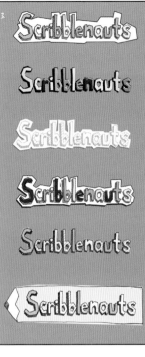

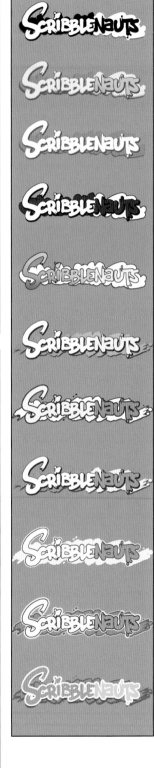

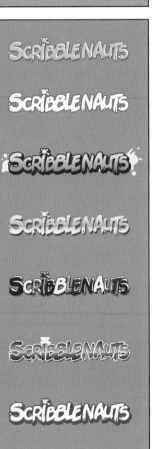

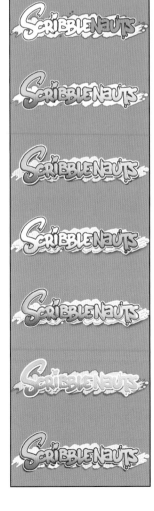

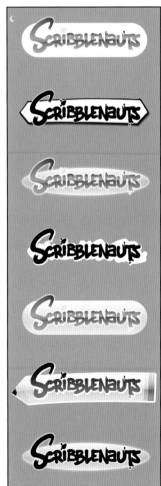

◆ LOGO CONCEPTS

◯ COMMENT

The logo is always challenging and fun. We did quite a few
iterations before we got the final one. *[Edison Yan]*

● LOGO CONCEPTS

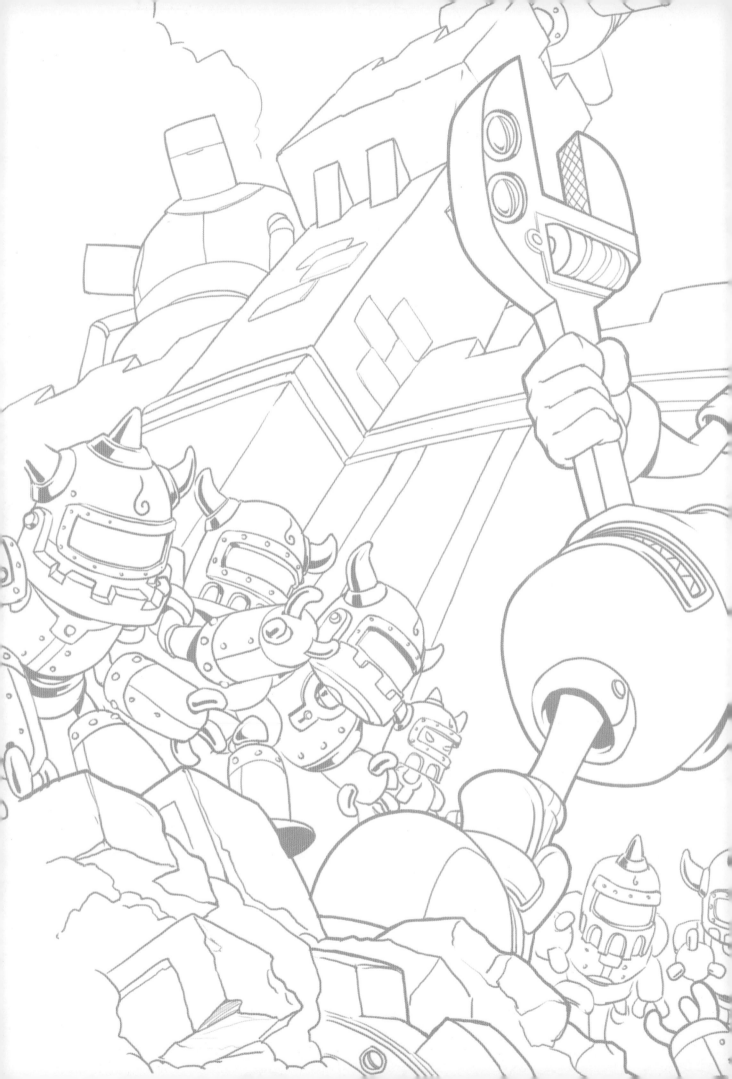

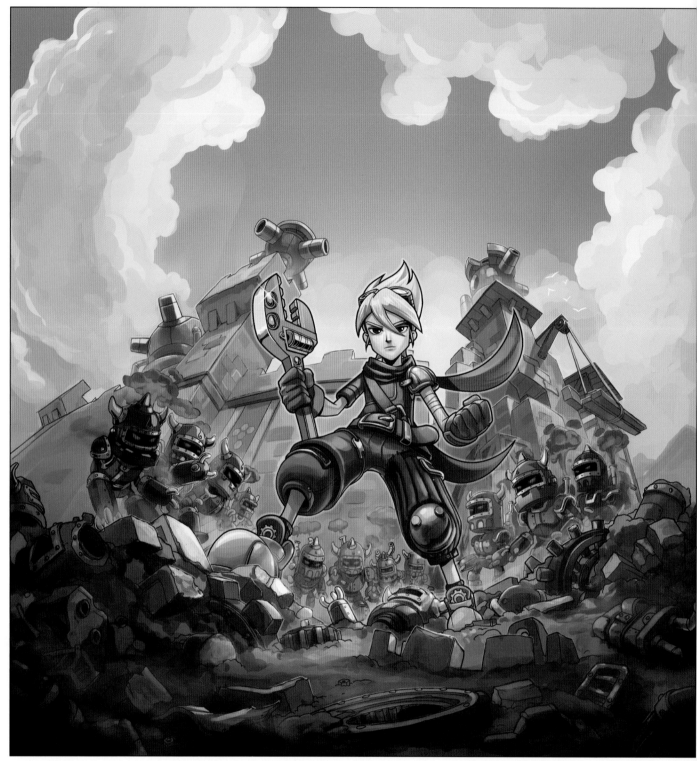

● LOCK'S QUEST - GAME BOX ART

Fresh off the success of *Drawn to Life*, we developed our second Nintendo DS title, which became known as *Lock's Quest*. Originally called "Snap Nation", the name was changed before launch due to some trademark concerns. Artistically, *Lock's Quest* paid homage to the Japanese RPG's that we all grew up playing. *[Joe Tringali]*

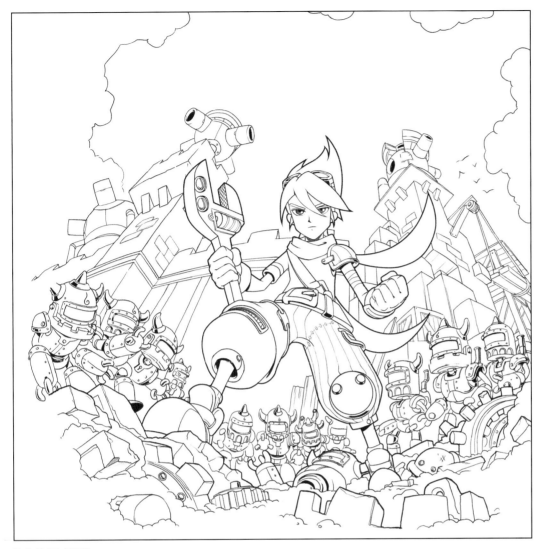

● LINE ART

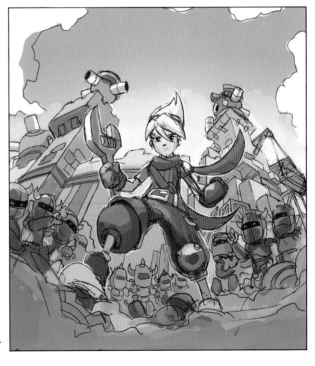

● ROUGH CONCEPT

⬡ LOCK

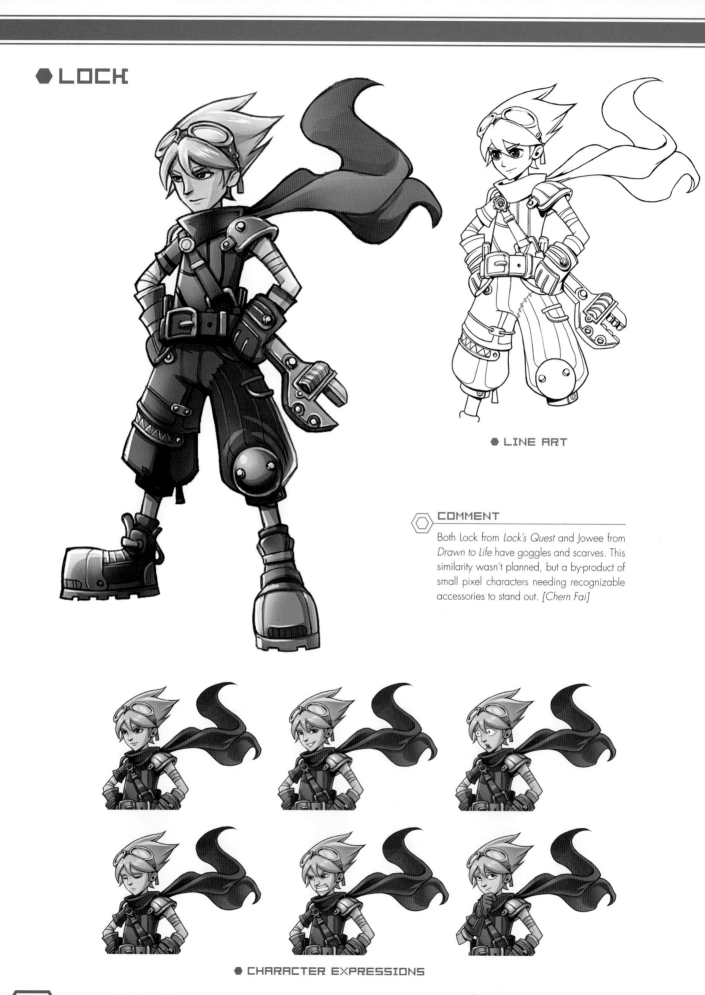

● LINE ART

⬡ COMMENT

Both Lock from *Lock's Quest* and Jowee from *Drawn to Life* have goggles and scarves. This similarity wasn't planned, but a by-product of small pixel characters needing recognizable accessories to stand out. *[Chern Fai]*

● CHARACTER EXPRESSIONS

● EMI

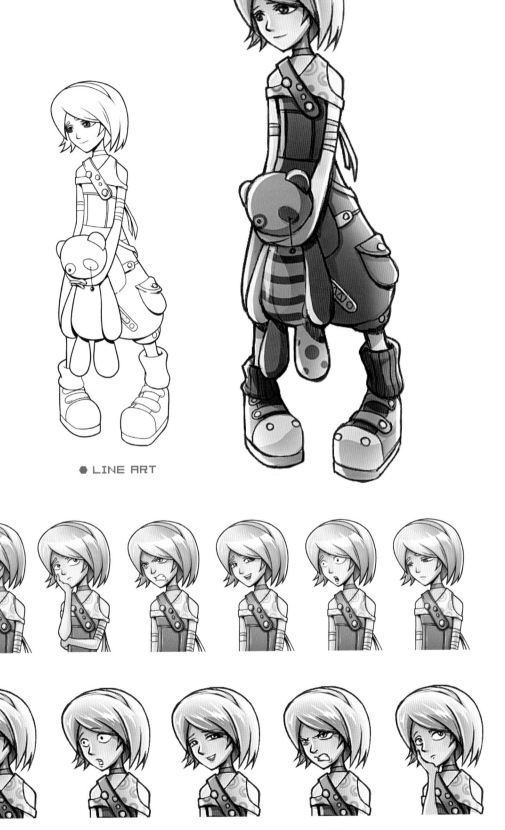

● LINE ART

● CHARACTER EXPRESSIONS

● TOBIAS

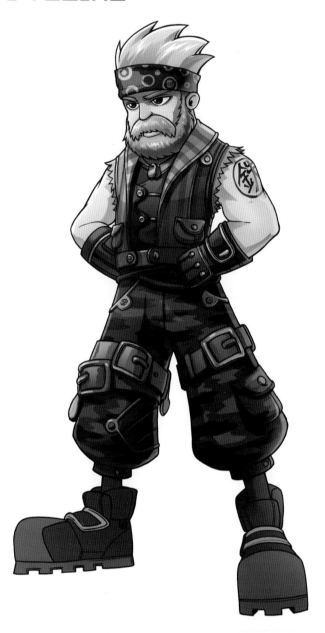

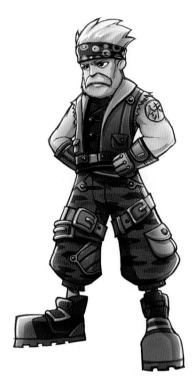

● ALTERNATE DESIGN

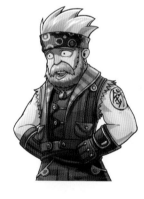 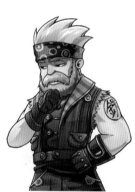

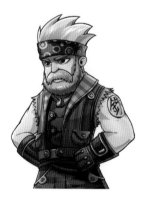 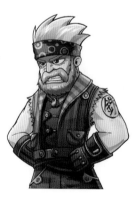 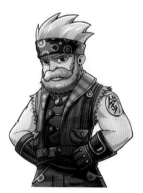

● CHARACTER EXPRESSIONS

● HEATHERN

● CHARACTER EXPRESSIONS

● KING

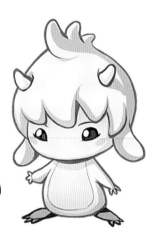

● BLUEBIT

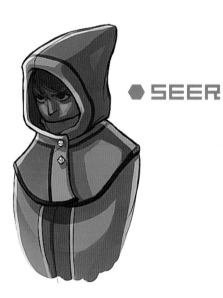

● SEER

● GENTZ

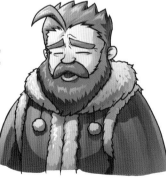 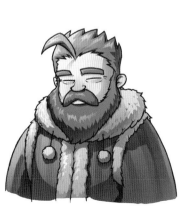 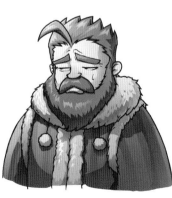

◆ ISAIAH

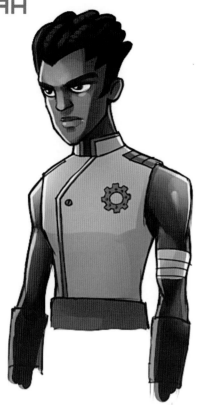

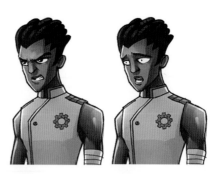

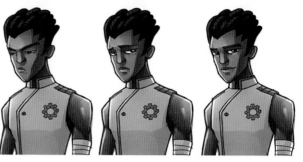

◆ CHARACTER EXPRESSIONS

◆ VETERAN

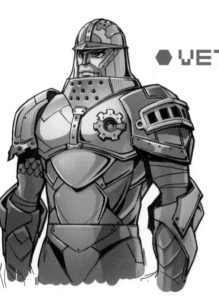

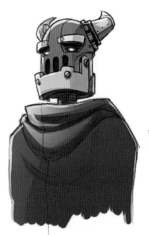

◆ WAR MACHINE

◆ KNIGHT

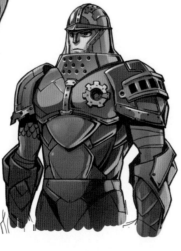

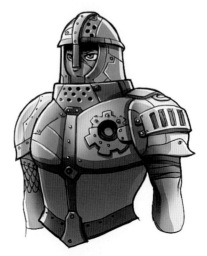

KENAN

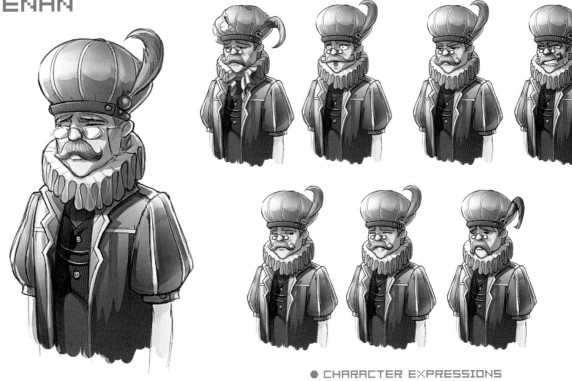

● CHARACTER EXPRESSIONS

LORD AGONY

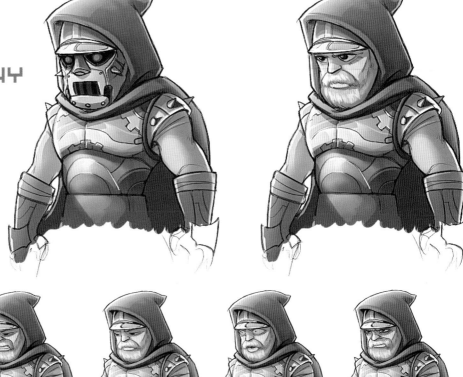

● CHARACTER EXPRESSIONS

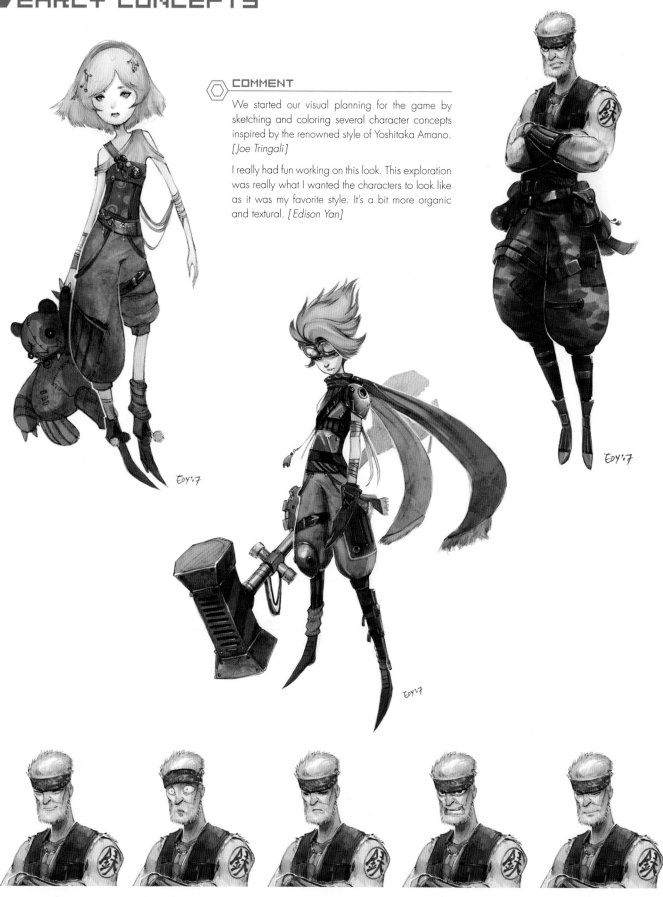

◇ COMMENT

We started our visual planning for the game by sketching and coloring several character concepts inspired by the renowned style of Yoshitaka Amano. [Joe Tringali]

I really had fun working on this look. This exploration was really what I wanted the characters to look like as it was my favorite style. It's a bit more organic and textural. [Edison Yan]

EARLY CONCEPTS

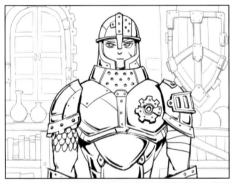

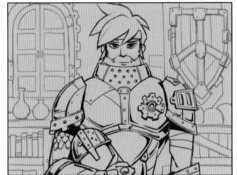

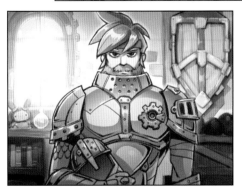

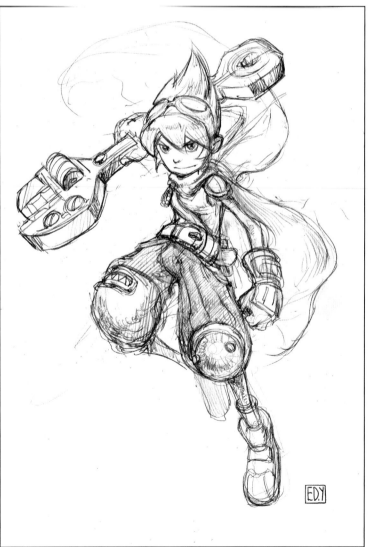

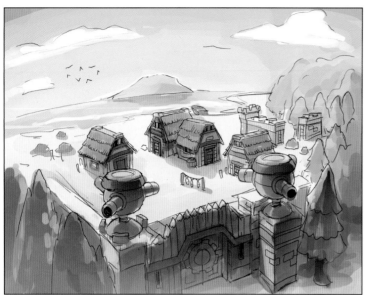

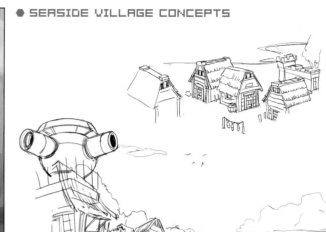

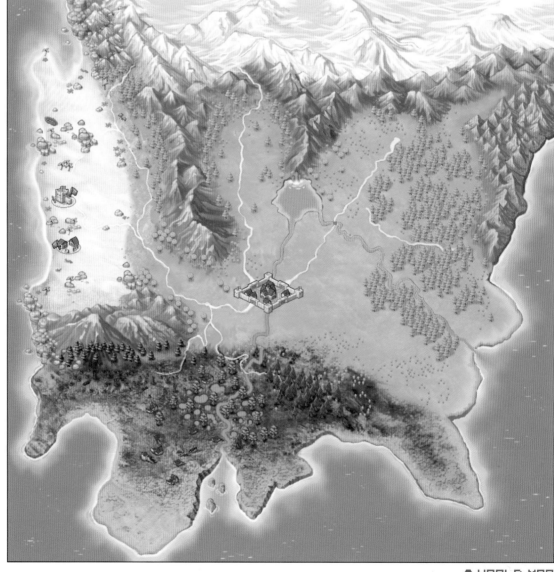

● WORLD MAP

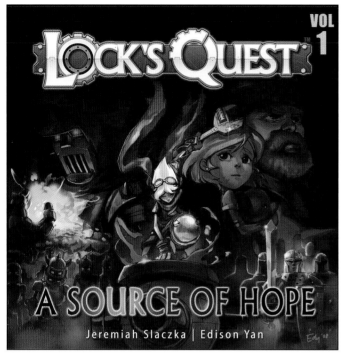

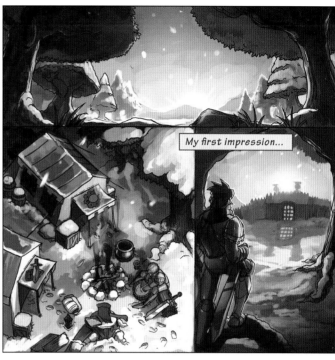

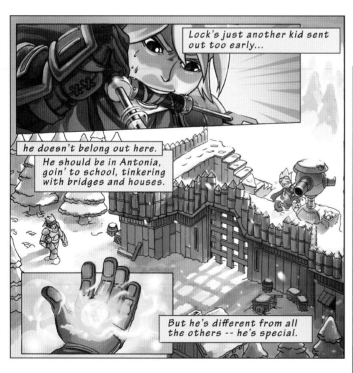

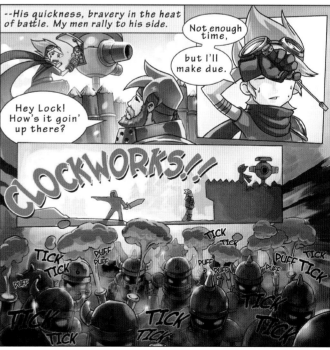

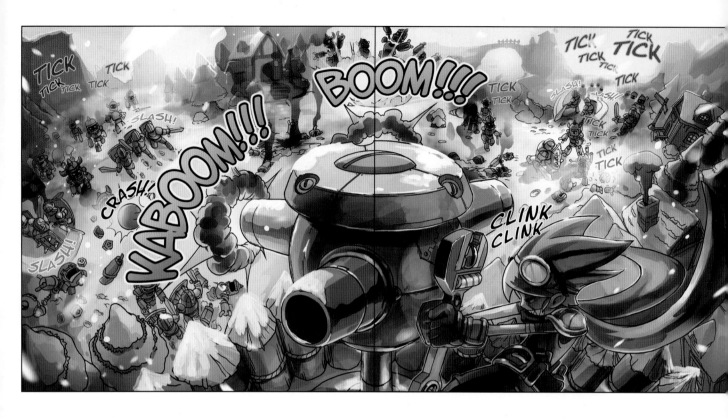

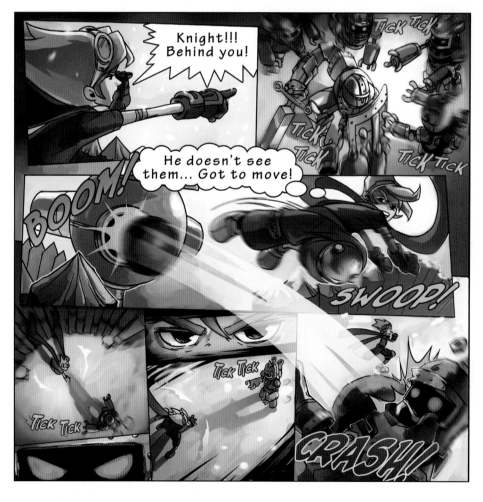

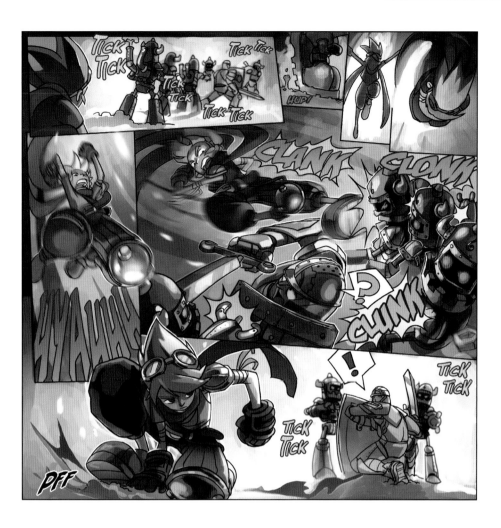

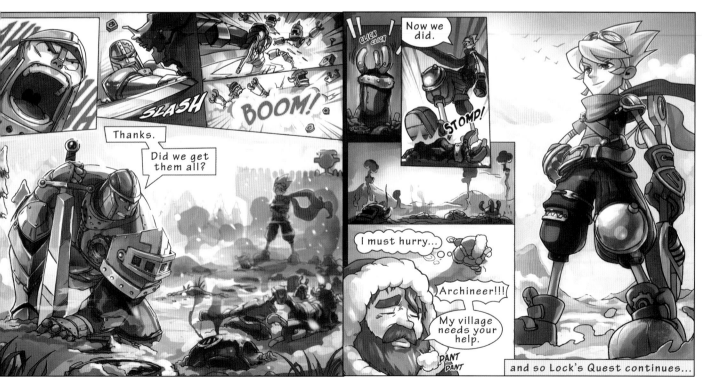

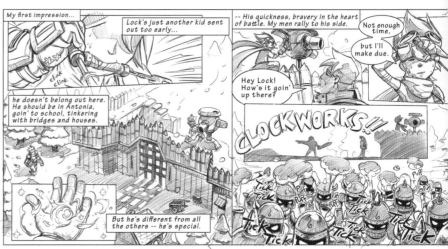

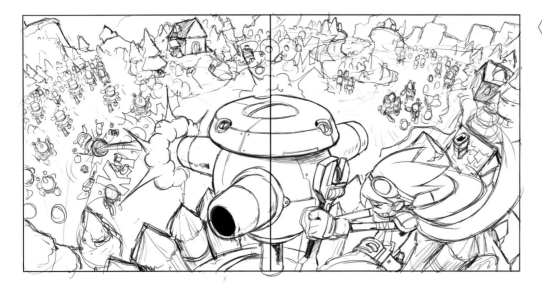

◯ COMMENT

It was really fun to work on mini projects with Jeremiah. This comic was one of those instances where the game was being promoted at SDCC, and what better way than to introduce the game through comic book storytelling. [Edison Yan]

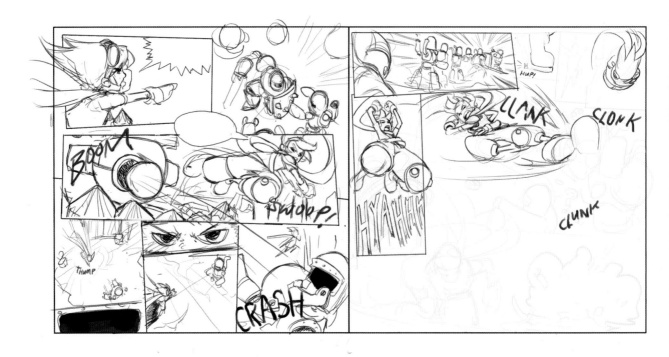

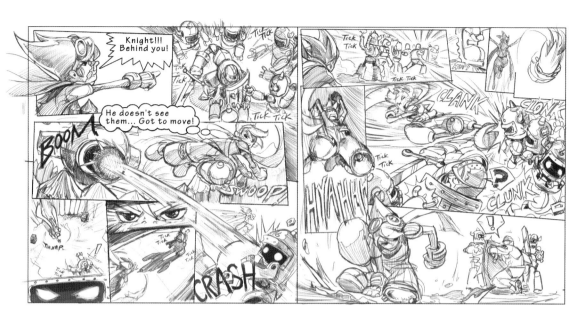

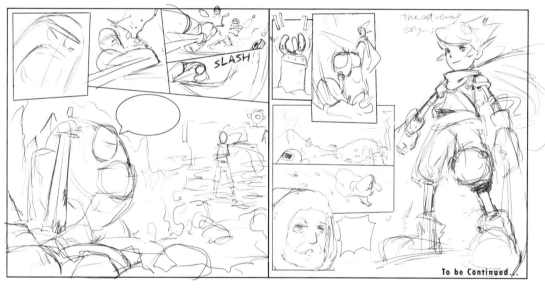

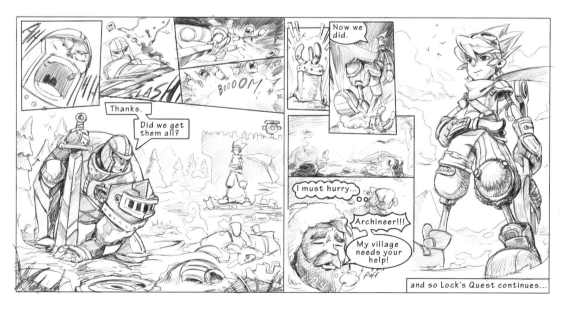

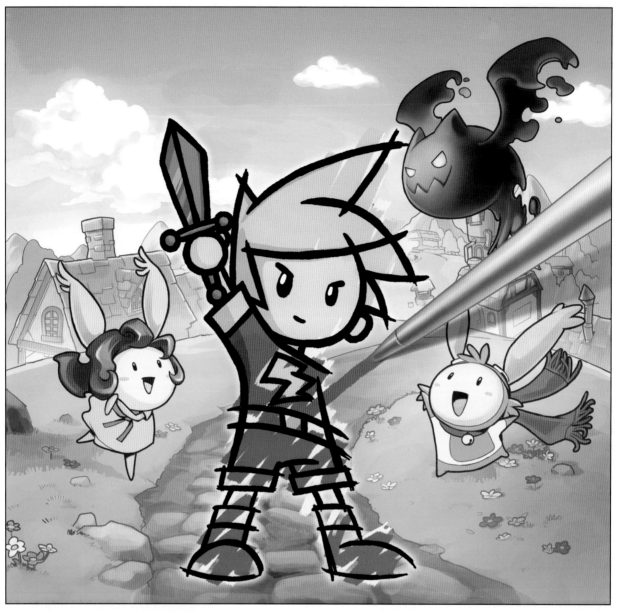

● DRAWN TO LIFE - GAME BOX ART

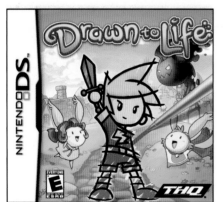

● GAME BOX ART WITH GRAPHICS

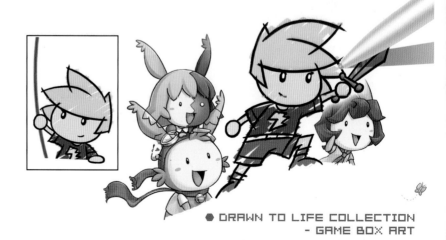

● DRAWN TO LIFE COLLECTION
- GAME BOX ART

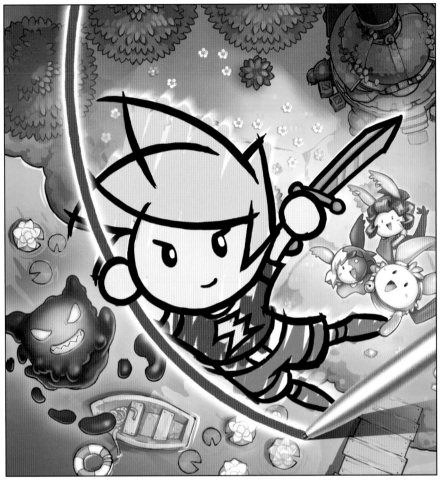

● DRAWN TO LIFE: THE NEXT CHAPTER - GAME BOX ART

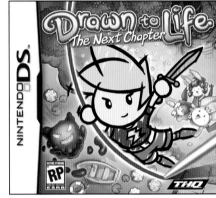

● GAME BOX ART
WITH GRAPHICS

● ROUGH CONCEPTS

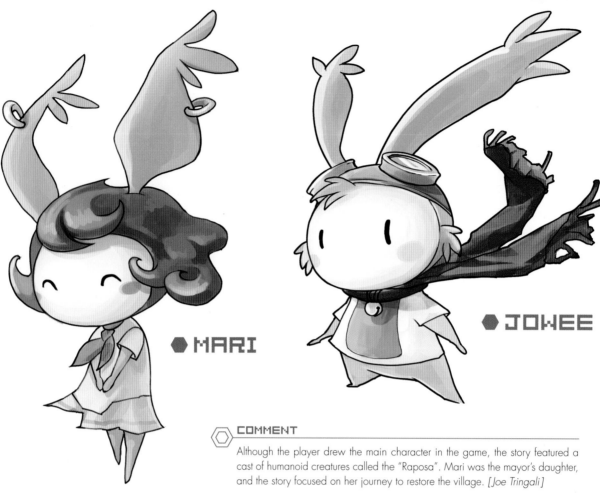

● MARI

● JOWEE

Although the player drew the main character in the game, the story featured a cast of humanoid creatures called the "Raposa". Mari was the mayor's daughter, and the story focused on her journey to restore the village. *[Joe Tringali]*

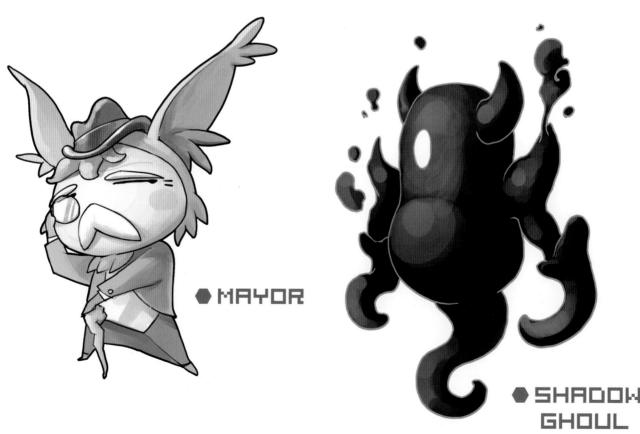

● MAYOR

● SHADOW GHOUL

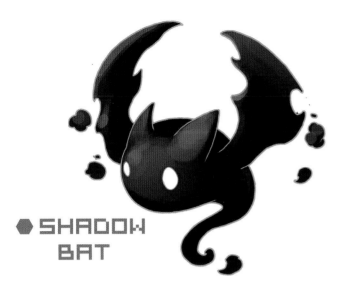

● SHADOW BAT

COMMENT

These are some initial concepts of the ink enemies for the first *Drawn to Life*. [Joe Tringali]

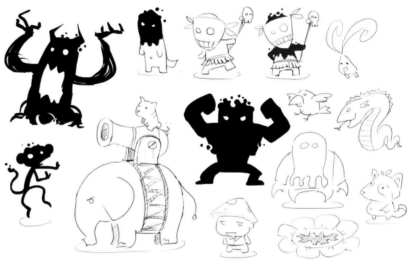

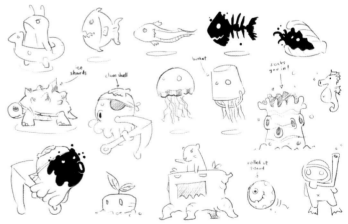

● ENEMY ROUGH CONCEPTS

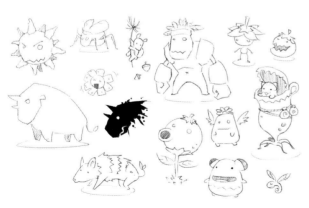

● RAPOSA VILLAGE

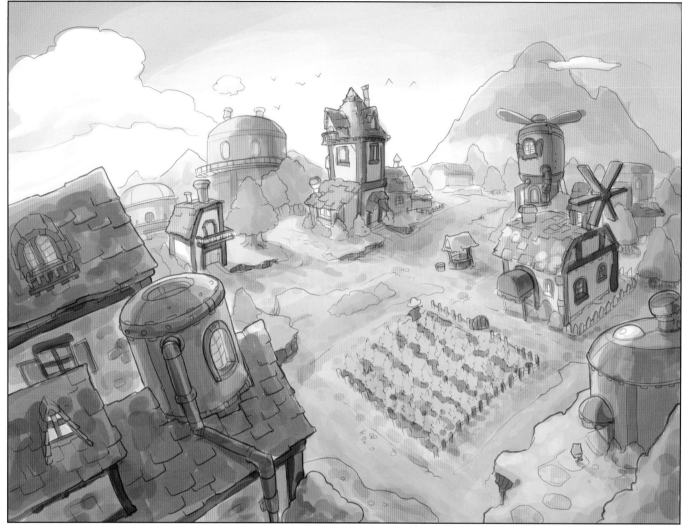

COMMENT

The village in *Drawn to Life* originally featured a background that changed depending on the time of day in the real world. *[Chern Fai]*

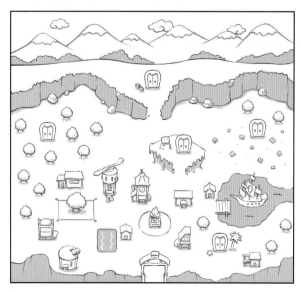

● EARLY VILLAGE MAP

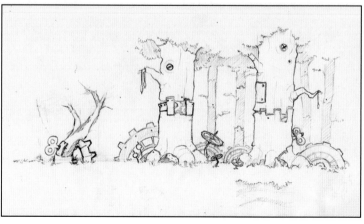

● CONCEPT FOR THE CLOCKWORK FOREST WORLD

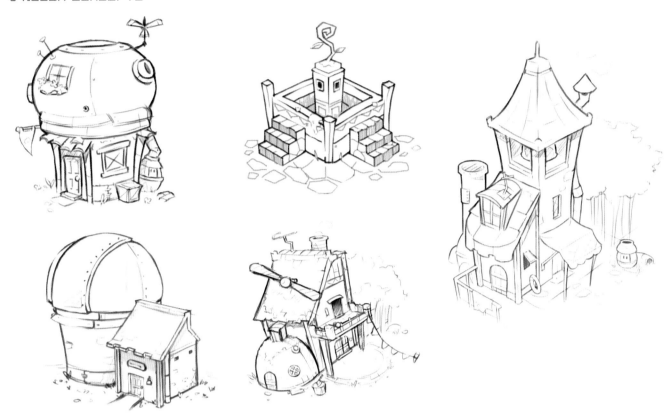

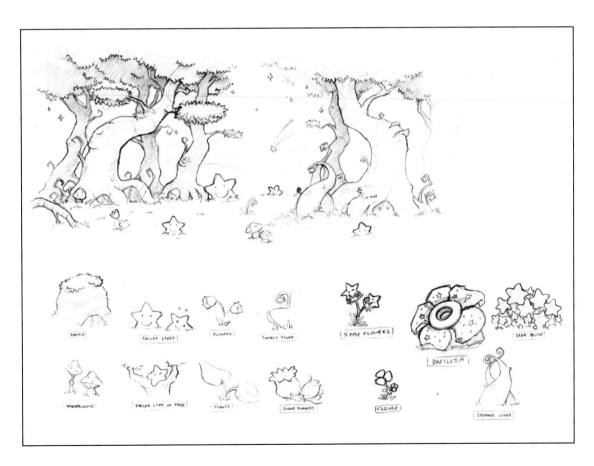

ROCKS

FALLEN STARS

FLOWERS

TWIRLY STUFF

STAR FLOWERS

RAFFLESIA

STAR BUSH

MUSHROOMS

FALLEN STAR ON TREE

PLANTS

GIANT FLOWERS

CLOVER

STRANGE VINES

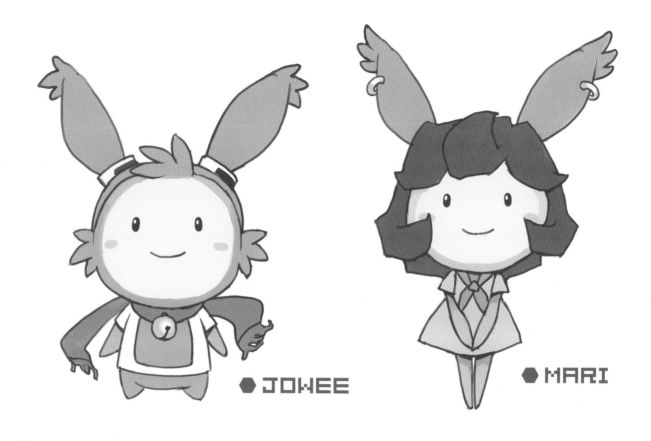

● JOWEE

● MARI

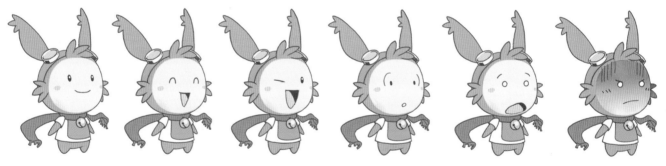

● CHARACTER EXPRESSIONS

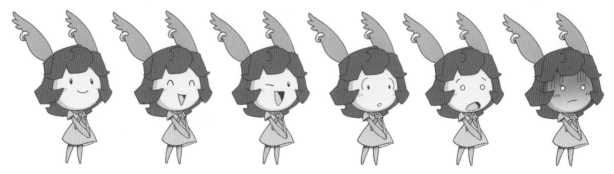

● CHARACTER EXPRESSIONS

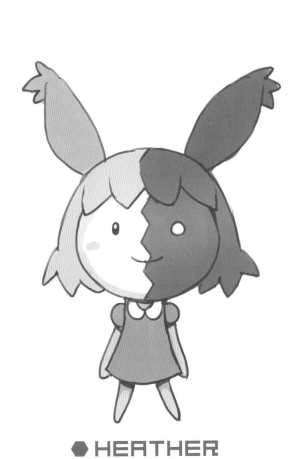

● HEATHER

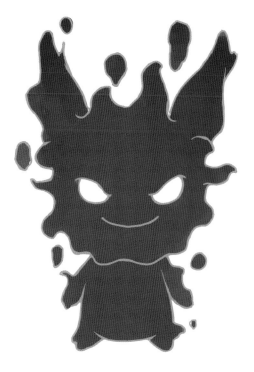

● WILFRE

COMMENT

Wilfre was the antagonist in both *Drawn to Life* games. We find out in *Drawn to Life: The Next Chapter* that Wilfre actually was a Raposa before he became corrupted by shadow. *[Joe Tringali]*

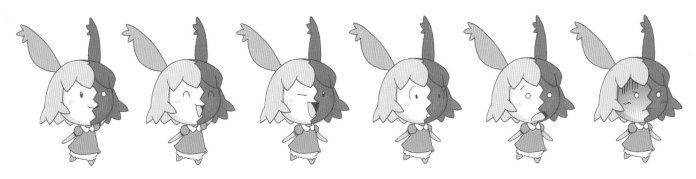

● CHARACTER EXPRESSIONS

COMMENT

Heather was half shadow / half Raposa. After her introduction in *Drawn to Life*, she played a major role in *Drawn to Life: The Next Chapter*. *[Joe Tringali]*

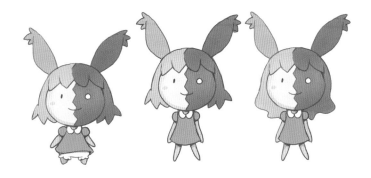

◆ RAPOSA DESIGNS

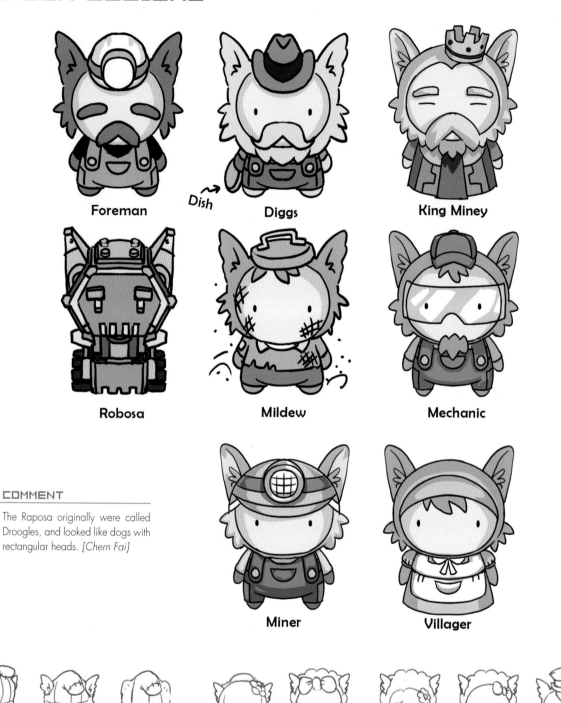

Foreman

Diggs *Dish* ↗

King Miney

Robosa

Mildew

Mechanic

Miner

Villager

⬡ COMMENT

The Raposa originally were called
Droogles, and looked like dogs with
rectangular heads. [Chern Fai]

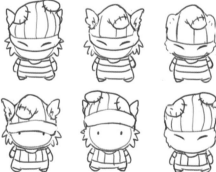
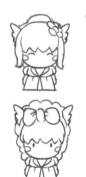

◆ ROUGH SKETCHES

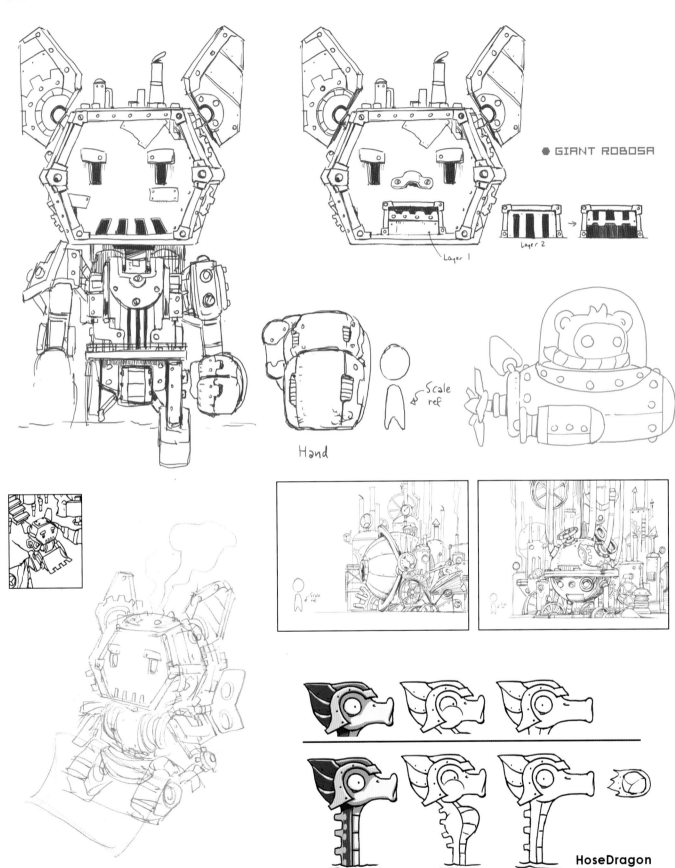

● GIANT ROBOSA

Layer 1

Layer 2

Hand

Scale ref

Scale ref

HoseDragon

◆ WILFRE'S ULTIMATE CREATION

● ENEMY ROUGH CONCEPTS

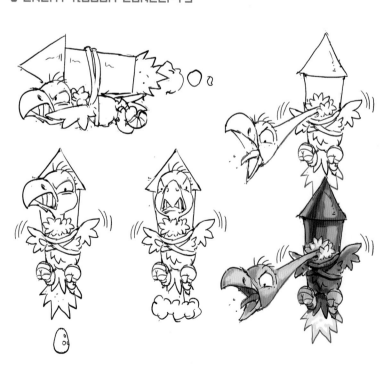
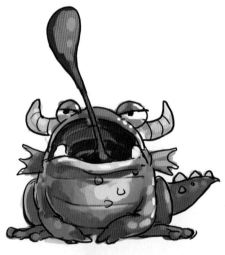
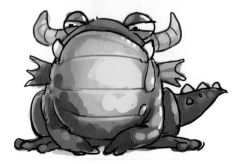

● DRAWN TO LIFE:
 THE NEXT CHAPTER
 - INTRO CINEMATIC

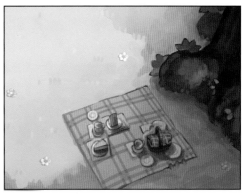

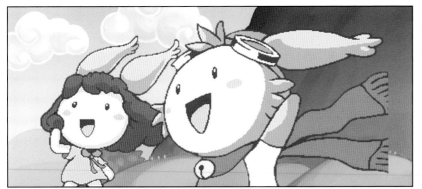

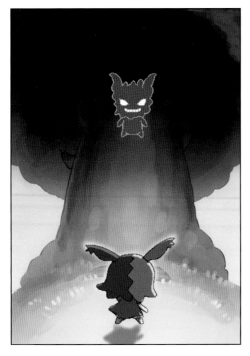

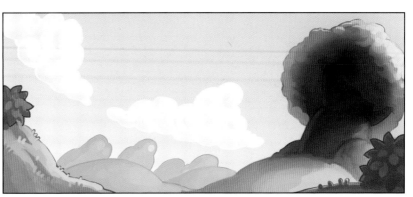

● DRAWN TO LIFE: THE NEXT CHAPTER
 - INTRO CINEMATIC [CONTINUED]

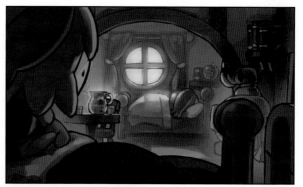
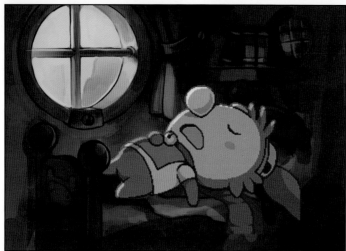

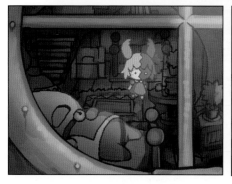

⬡ COMMENT

This opening intro is definitely one of my favorite things I've had the opportunity to work on at 5TH Cell. Jeremiah came up with the story, I drafted the storyboard and colored the backgrounds, Paul Robertson animated the characters, and David Franco did the music. In the end, I felt it was really special to be able to see the characters in a different world, other than the sprite world. It was almost like another dimension, because they had facial expression, closeup shots and body language. In the game, you rarely got to see that. *[Edison Yan]*

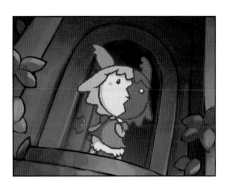
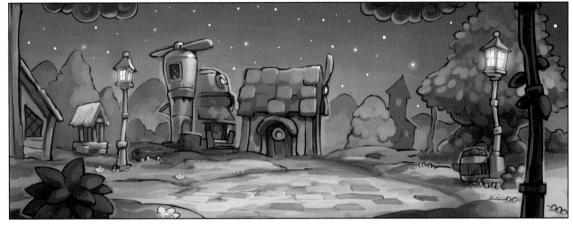
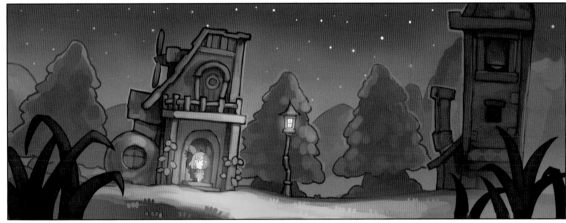

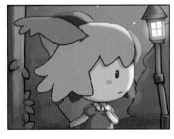
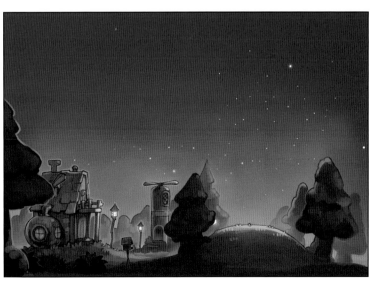

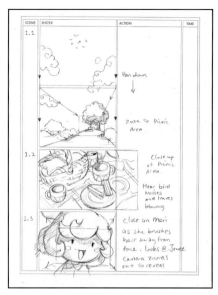

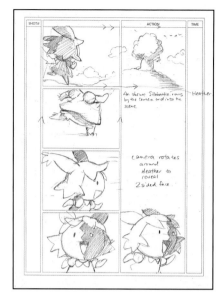

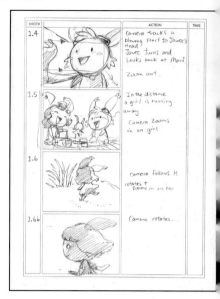

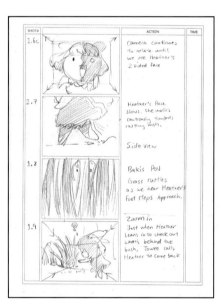

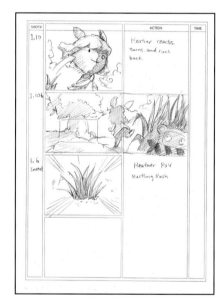

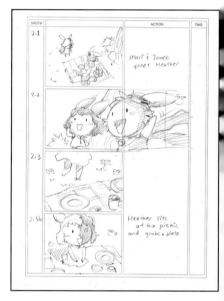

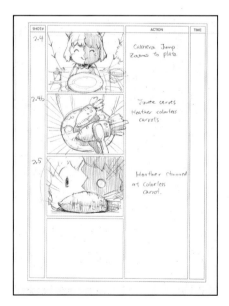

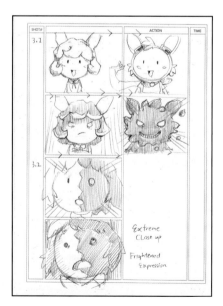

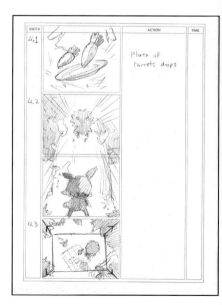

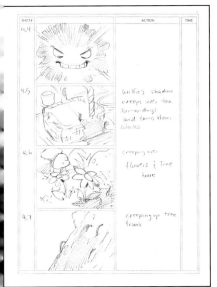

COMMENT

What's interesting about the storyboarding process, is that the initial storyboards were done on post-it notes. This is a slightly cleaned up version just before the animatic was generated. [Edison Yan]

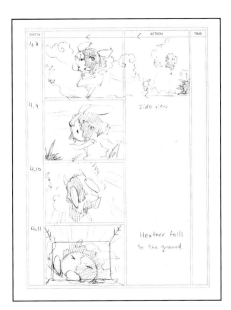

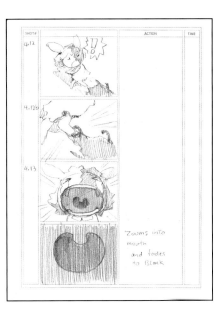

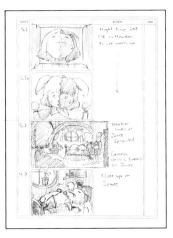

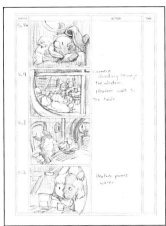

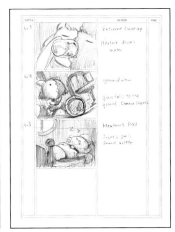

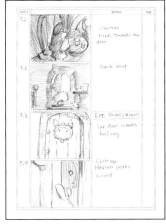

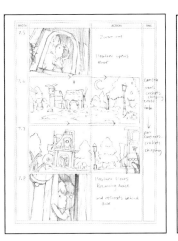

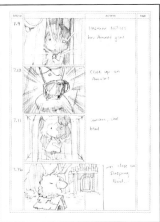

● TURTLE ROCK

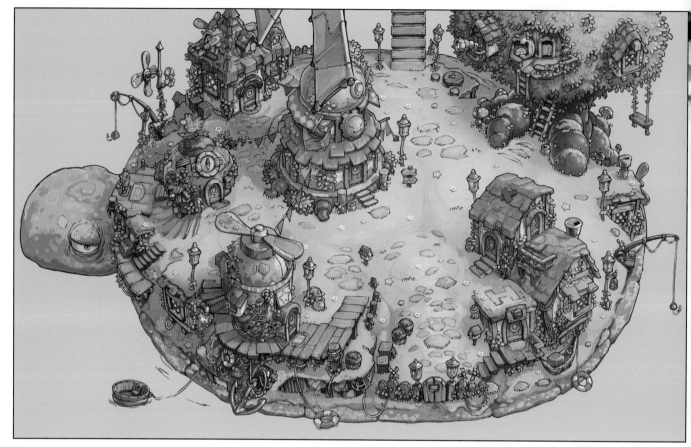

● MAP ARTWORK

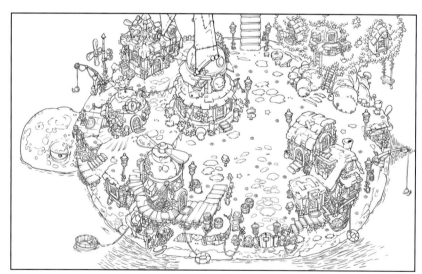

● LINE ART

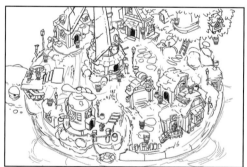

● ROUGH SKETCHES

◇ COMMENT

The original village was lost at the start of *Drawn to Life: The Next Chapter*, and the Raposa spent most of the second game in a new village on the back of a giant turtle. *[Joe Tringali]*

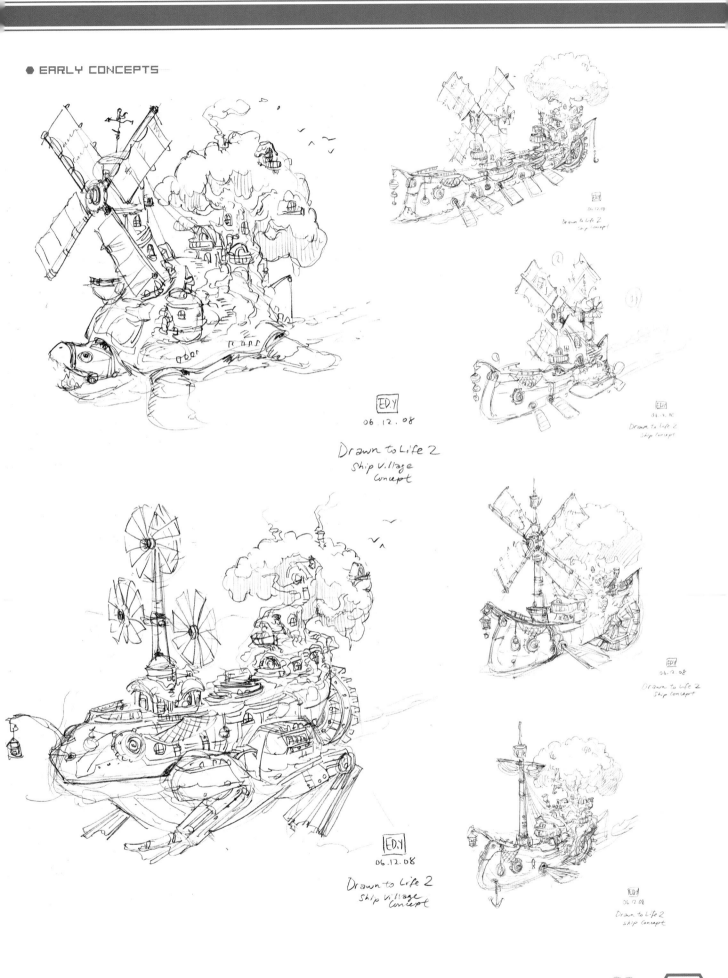

ED.Y
06.12.08

Drawn to Life 2
Ship Village
Concept

ED.Y
06.12.08

Drawn to Life 2
Ship Village
Concept

Drawn to Life 2
Ship Concept

Drawn to Life 2
Ship Concept

Drawn to Life 2
Ship Concept

RAPOSA VILLAGE

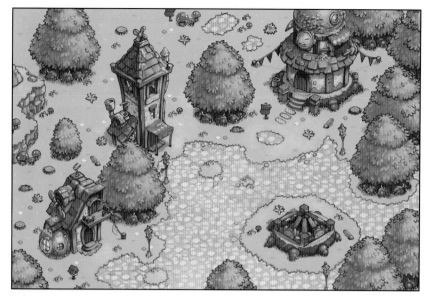

● LINE ART/ ROUGH SKETCH

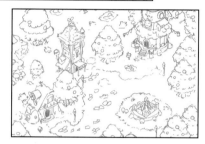

● MAP ARTWORK

HARBOR AREA

COMMENT

All environments in *Drawn to Life: The Next Chapter* were hand drawn. [Joe Tringali]

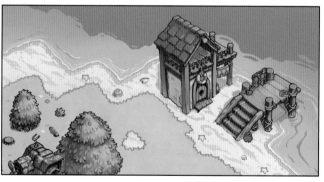

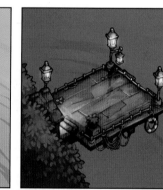

● MAP ARTWORK

● LINE ART

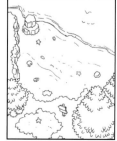

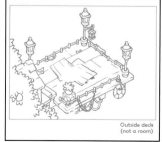

Outside deck
(not a room)

Outside deck
(not a room)

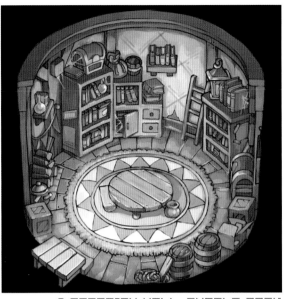

● CREATION HALL, TURTLE ROCK

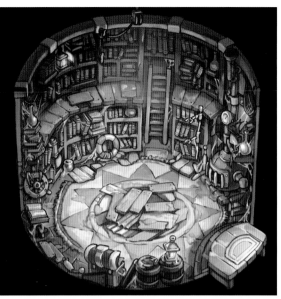

● CREATION HALL, VILLAGE

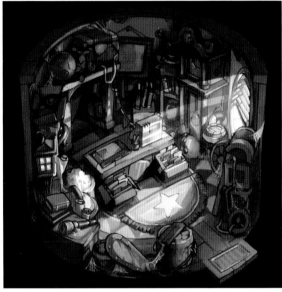

● ISAAC'S SHOP

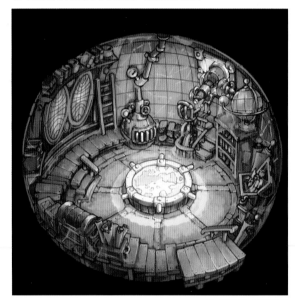

● MAP ROOM

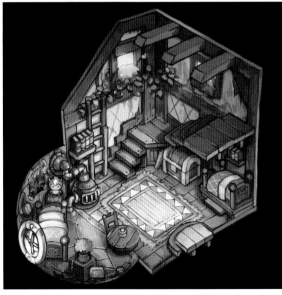

● JOWEE'S ROOM, VILLAGE

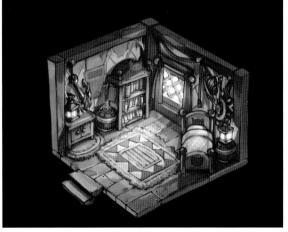

● JOWEE'S ROOM, TURTLE ROCK

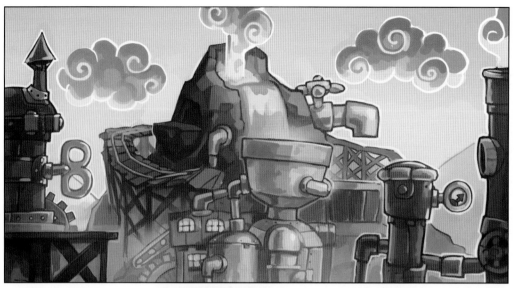

● WORLD SELECT IMAGE - LAVASTEAM

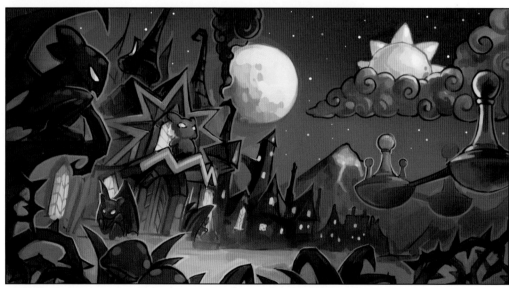

● WORLD SELECT IMAGE - WILFRE'S WASTELAND

● LEVEL BACKGROUNDS

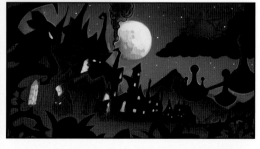

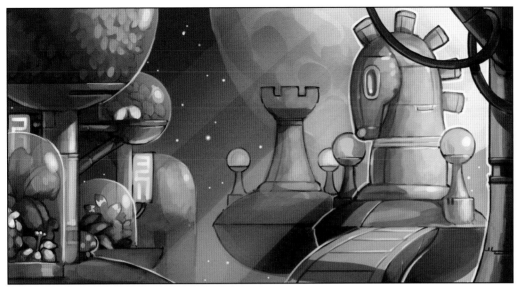

● WORLD SELECT IMAGE - GALACTIC JUNGLE

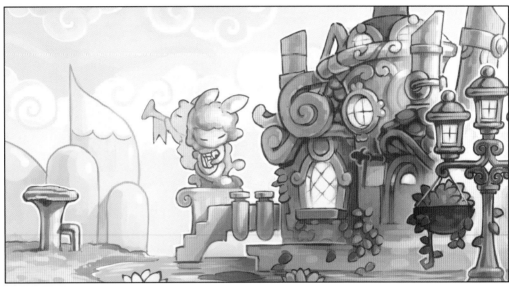

● WORLD SELECT IMAGE - WATERSONG

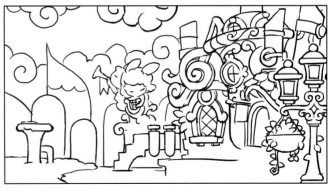

● ROUGH SKETCHES

◆ LAVASTEAM

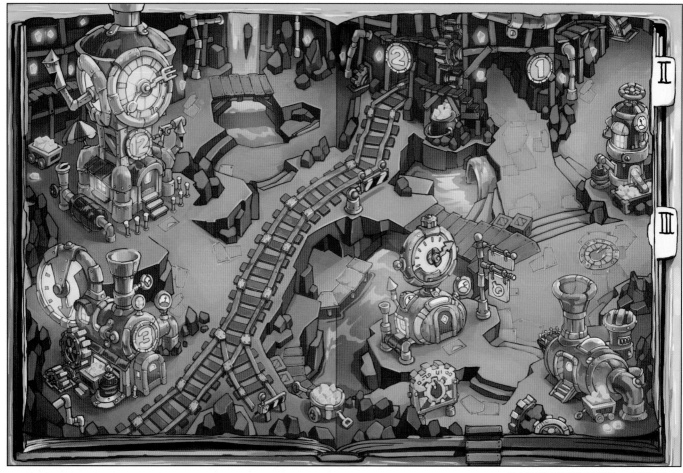

● MAP ARTWORK - PAGE 1

● EARLY VERSION

⬡ COMMENT

The lava world was the first world I got to design. The first pass on it was much darker and busier. I decided to simplify it and go with a slightly lighter palette in the end as it complimented the characters better. [Edison Yan]

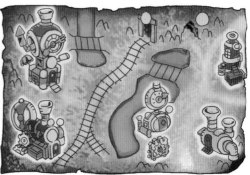

● MINI MAP

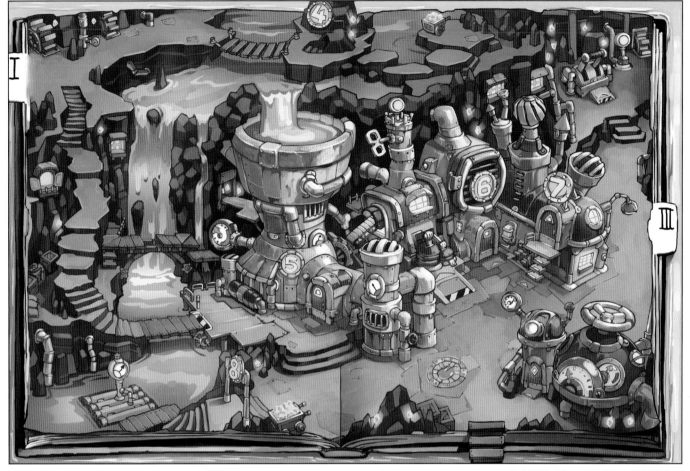

● MAP ARTWORK - PAGE 2

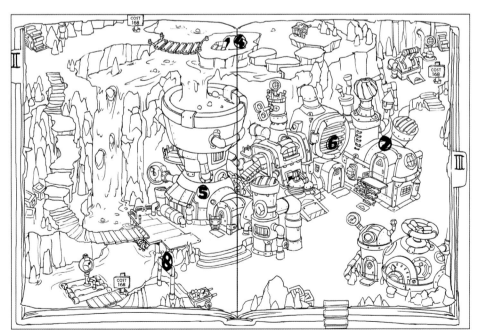

● LINE ART

● ROUGH CONCEPT

● LAVASTEAM

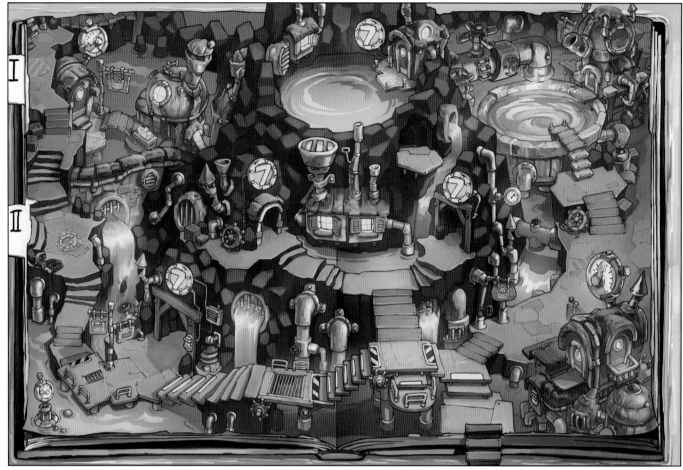

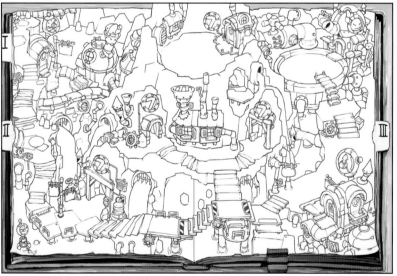

● LINE ART

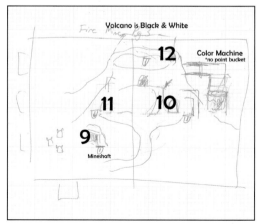

Volcano is Black & White

Color Machine
*no paint bucket

12

11 10

9

Mineshaft

● ROUGH CONCEPT

● ROUGH CONCEPTS/SKETCHES

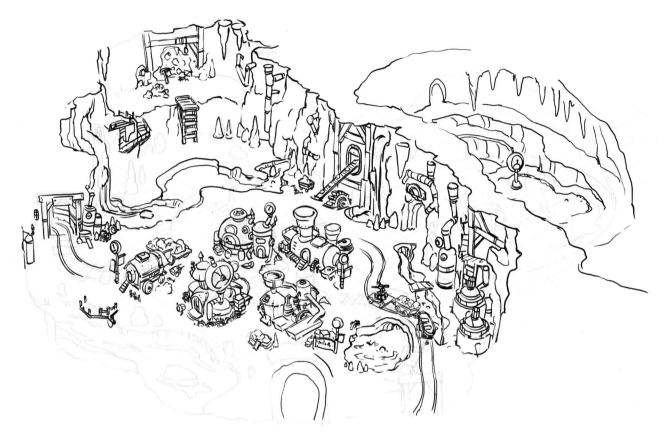

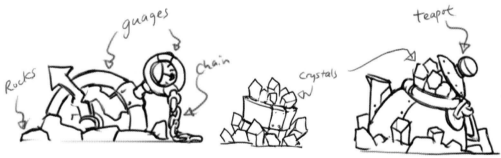

guages

teapot

Rocks

chain

crystals

● LEVEL BACKGROUNDS

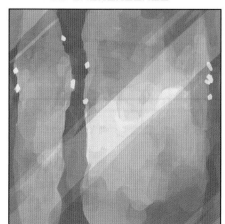

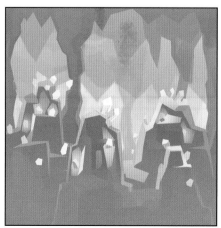

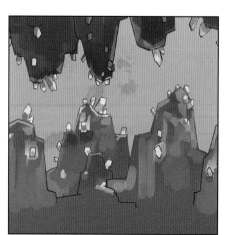

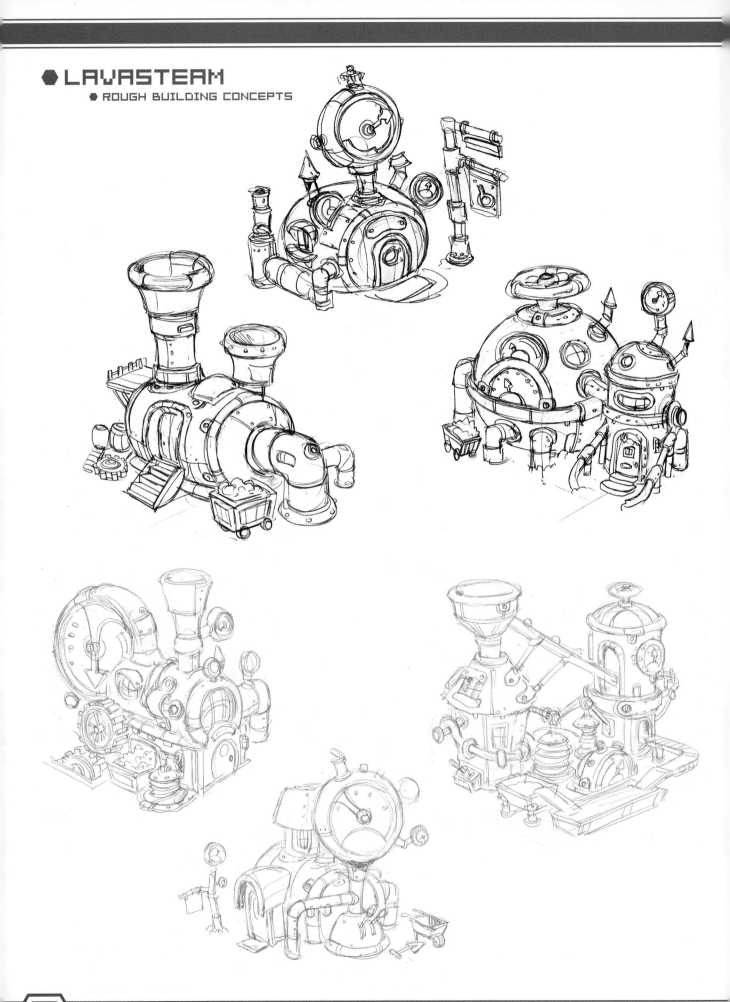

● LAVASTEAM TILESET PLANNING

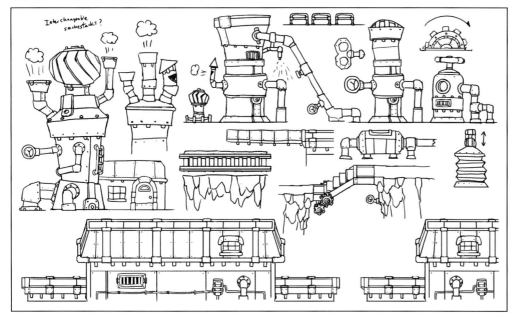

Interchangeable smokestacks?

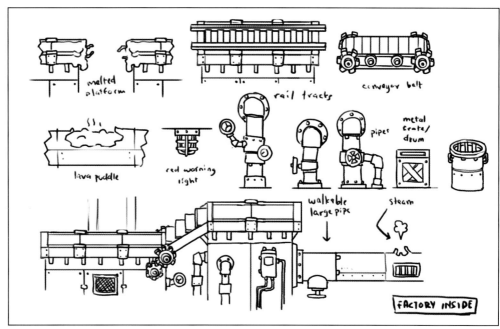

melted platform

rail tracks

conveyer belt

lava puddle

red warning light

pipes

metal crate/ drum

walkable large pipe

steam

FACTORY INSIDE

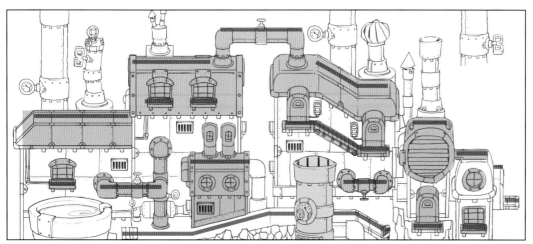

● GALACTIC JUNGLE

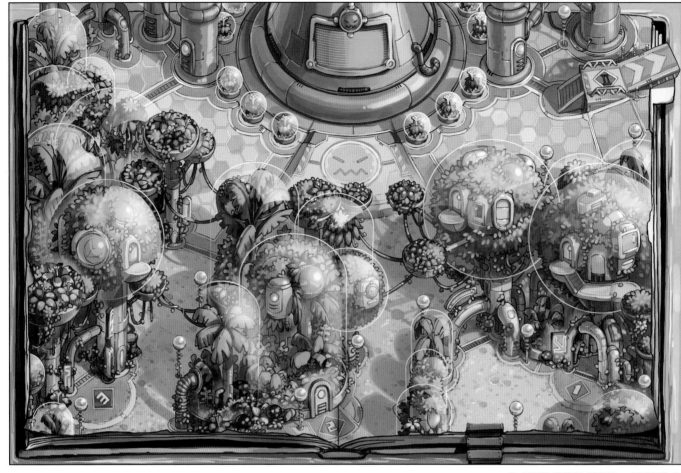

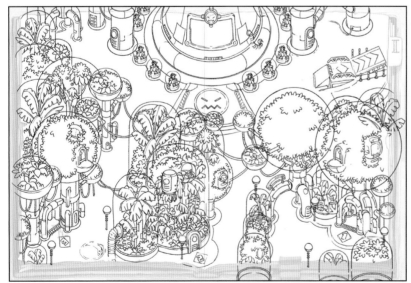

● LINE ART

COMMENT

Creating the world pages were really challenging. We need to incorporate all the necessary story components, but at the same time, I really wanted to make it visually interesting and not so one dimensional. So when I could, I tried to give a sense of verticality to the otherwise monotonous ground plane. [Edison Yan]

● ROUGH SKETCH

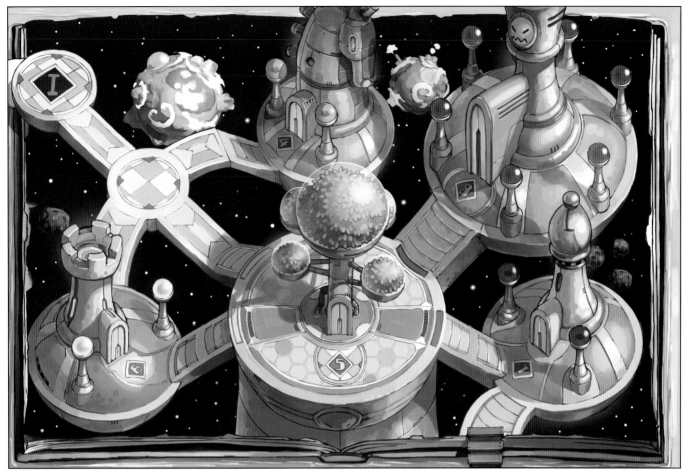

● MAP ARTWORK - PAGE 2

● LINE ART

● ROUGH SKETCH

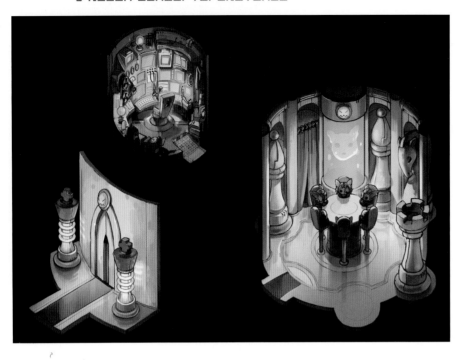

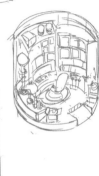

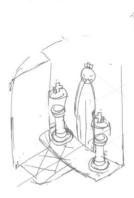

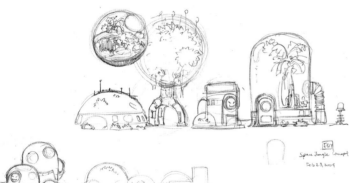

Space Jungle
Feb 23, 2009

Space Jungle Concept
Feb 23, 2009

Space Jungle
Village Concept
Feb 23, 2009

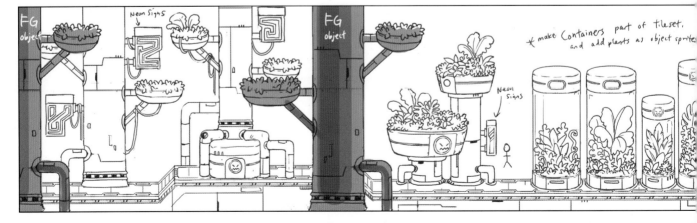

Neon Signs

FG object

FG object

Neon Signs

* make containers part of tileset,
and add plants as object sprites

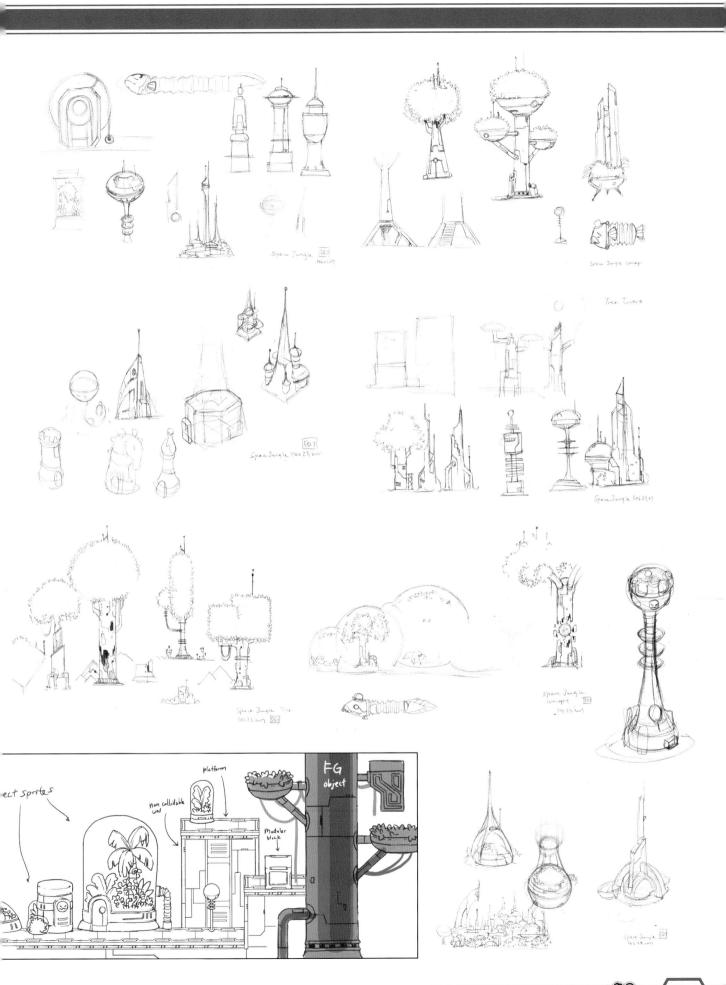

● WILFRE'S WASTELAND

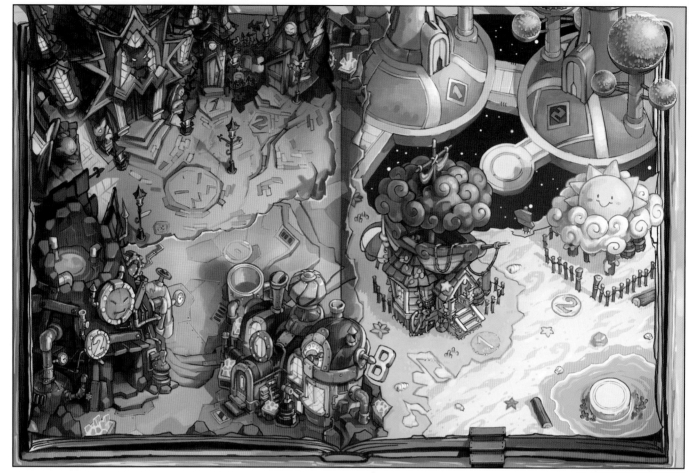

● MAP ARTWORK

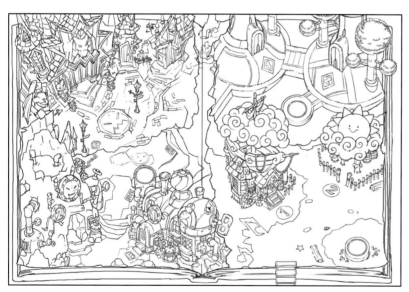

● LINE ART

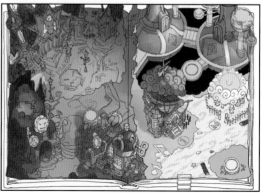

● ROUGH CONCEPTS

● ROUGH BUILDING CONCEPTS

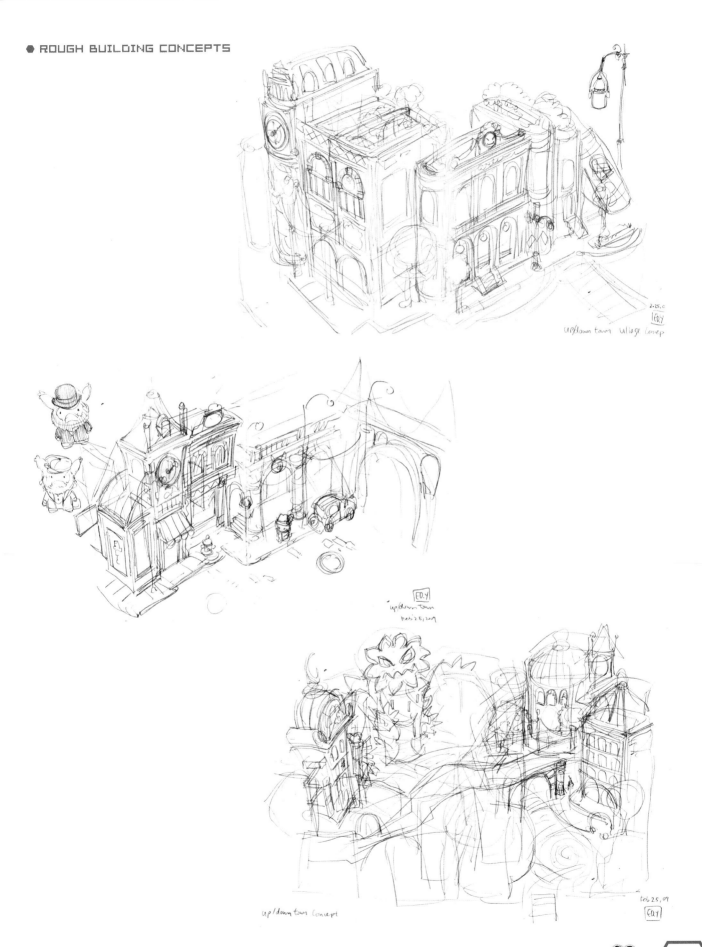

⬢ WATERSONG

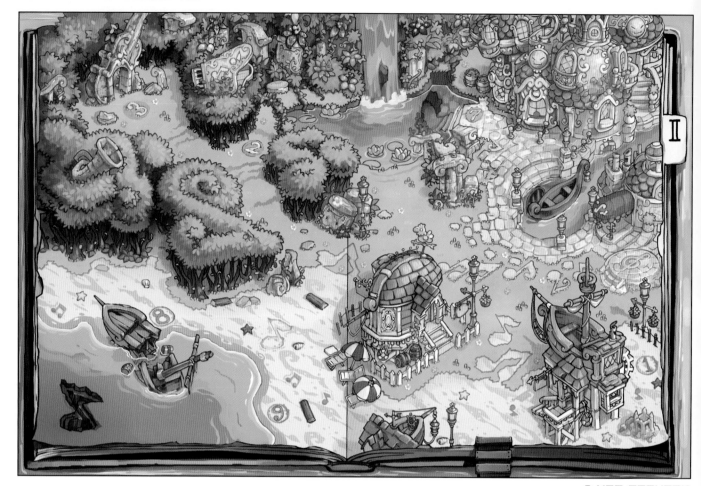

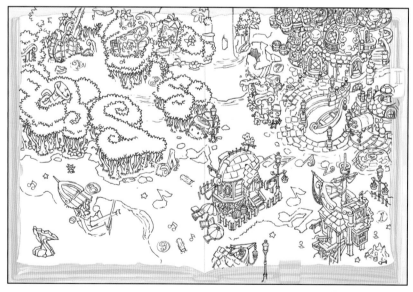

● LINE ART

● ROUGH CONCEPT

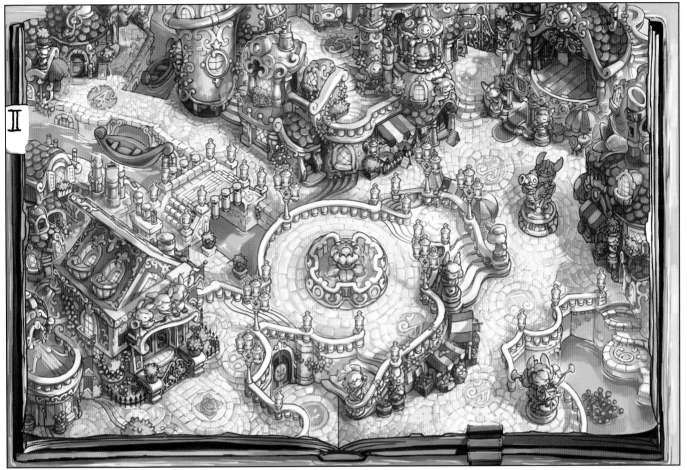

● MAP ARTWORK

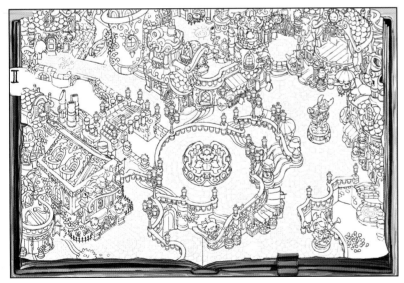

● LINE ART

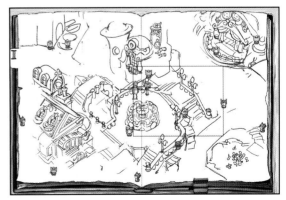

● ROUGH CONCEPT

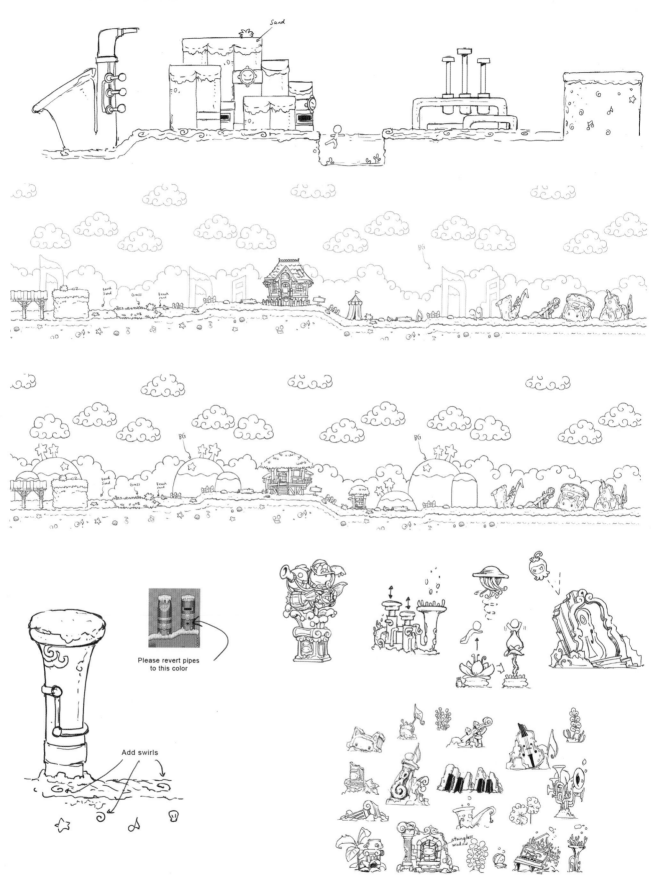

Sand

Please revert pipes
to this color

Add swirls

COMMENT

Watersong was my favorite world to work on because it was very ornate and very European looking. I'm a huge fan of European architecture and influences. In the end, I love how the buildings turned out. *[Edison Yan]*

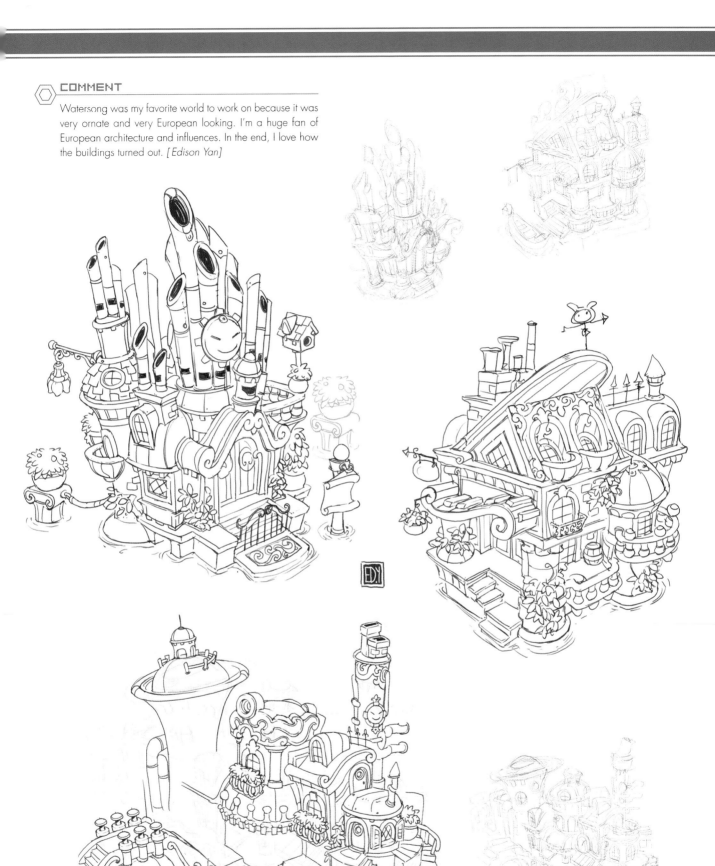

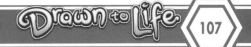

WATERSONG
ROUGH CONCEPTS/SKETCHES

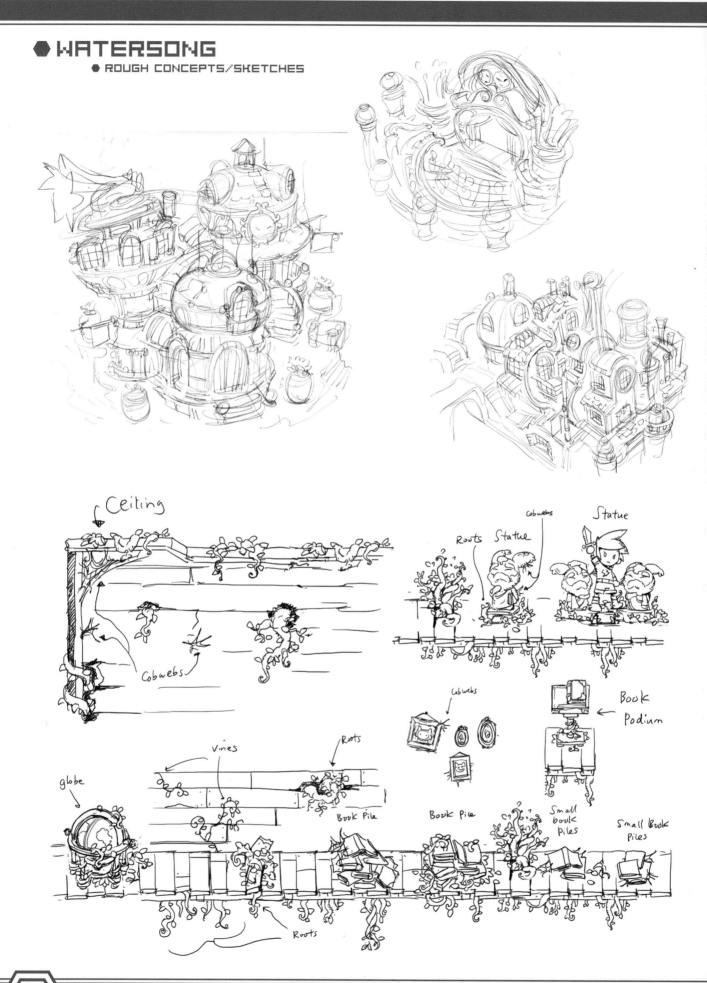

Ceiling

Cobwebs

Roots Statue Cobwebs Statue

Cobwebs

Book Podium

vines

Roots

globe

Book Pile Book Pile Small book piles Small Book Piles

Roots

Grime

Hole

Grime

Player walk path

Overlay object

Tilable any Length

Tilable any Height

Exterior Details
1) Captains Steering Wheel
2) Crow's Nest with Telescope
3) Windows
4) Cannon ports (Opened and Closed)
5) Rails
6) Masts
7) Barrels
8) Net Ladders
9) Figurehead bow of ship
10) Stern of ship.

Pirate ship should look old and weathered.
A haunted shipwreck. Think "Pirates of the Caribbean"
Sails are shredded. Ropes worn or snapped.
Flags tattered (Like Baki Skull and Crossbones)

Rust

Grime

wet water

*Please Make Pirate Ship Exterior colors
similar to the dark/damp Interior.

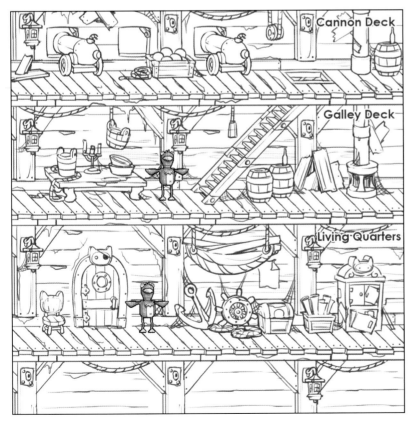

Cannon Deck

Galley Deck

Living Quarters

● WATERSONG - ROSE'S MANSION

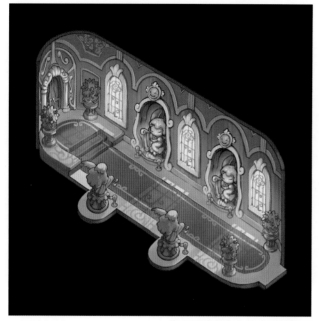

● MANSION INTERIOR

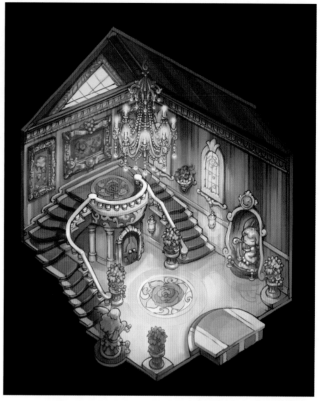

● MANSION INTERIOR

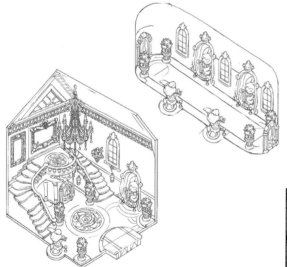

● LINE ART

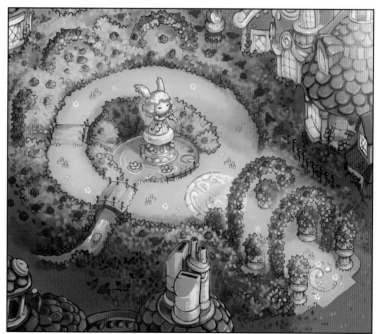

● ROSE GARDEN

● LEVEL PLANNING

⬡ COMMENT

After doing Rose's mansion, I really
wanted to do ALL the building interiors
of Watersong. Of course that would
mean extra work for me, and in the end
it didn't happen. But In my head, I was
like, "Wow... how cool would it be if
you could walk into all the buildings?"
One can only dream. *[Edison Yan]*

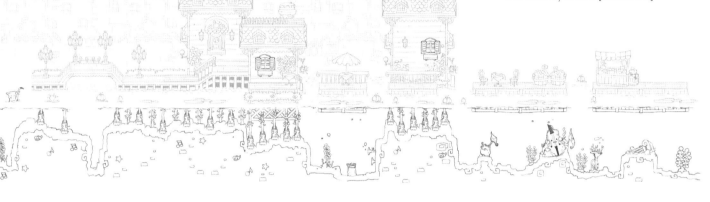

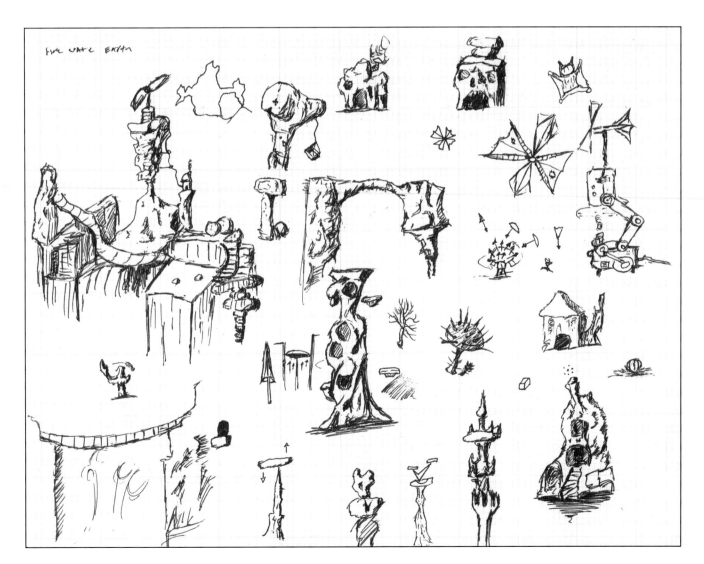

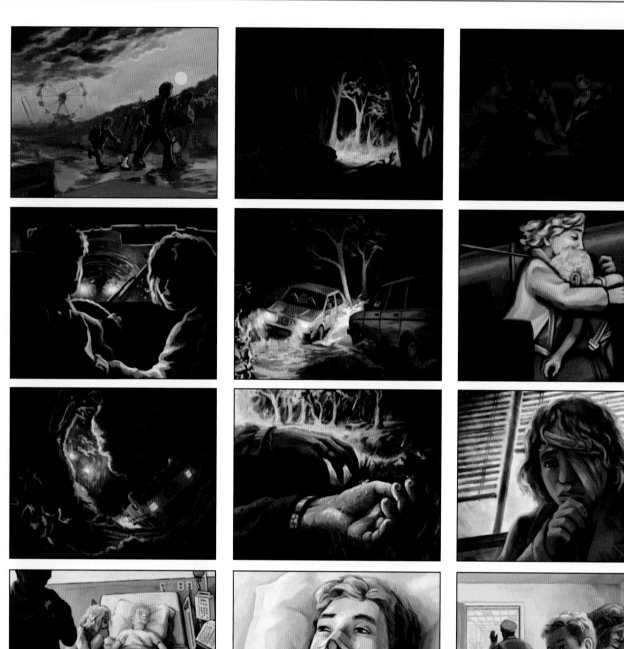

COMMENT

The original ending for *Drawn to Life: The Next Chapter* was purposely done in a different style from the game, to reinforce the real world vs. imagined world. Following a ratings complaint, the ending was modified for the *Drawn to Life: Collection*. [Joe Tringali]

● DRAWN TO LIFE: THE NEXT CHAPTER
 - END CREDITS SEQUENCE 1

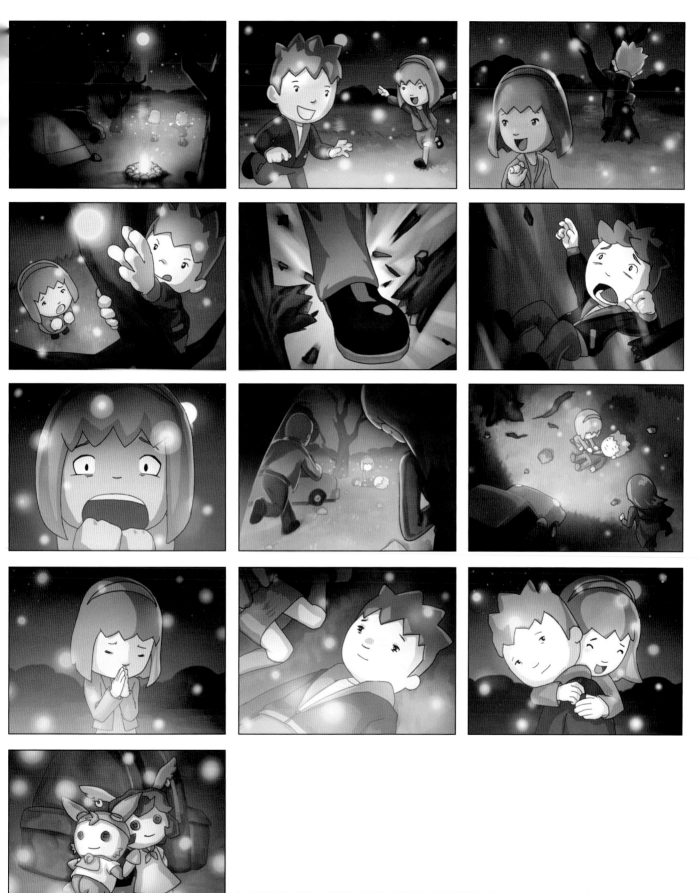

● DRAWN TO LIFE: THE NEXT CHAPTER
 - END CREDITS SEQUENCE 2

● CREATURE CONCEPTS

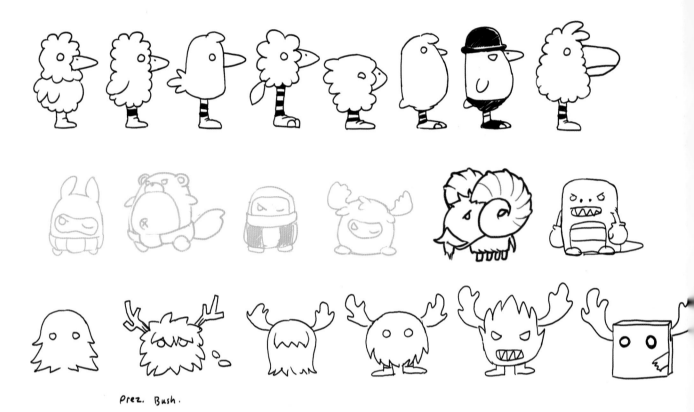

Prez. Bush.

● WORLD SELECT ICONS

Mine Village Easel

WaterSong Easel

Mine Village Easel

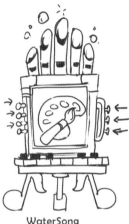

WaterSong Easel

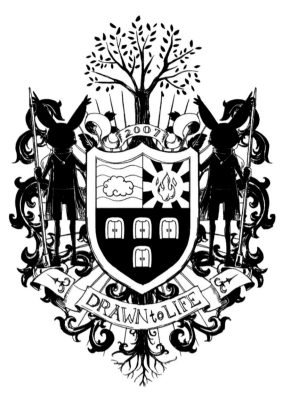

● COAT OF ARMS

◇ COMMENT

Maxwell and Jowee together. Both Drawn to Life *and* Scribblenauts *were bestselling original franchises on the Nintendo DS.* [Joe Tringali]

● WEBSITE BANNERS

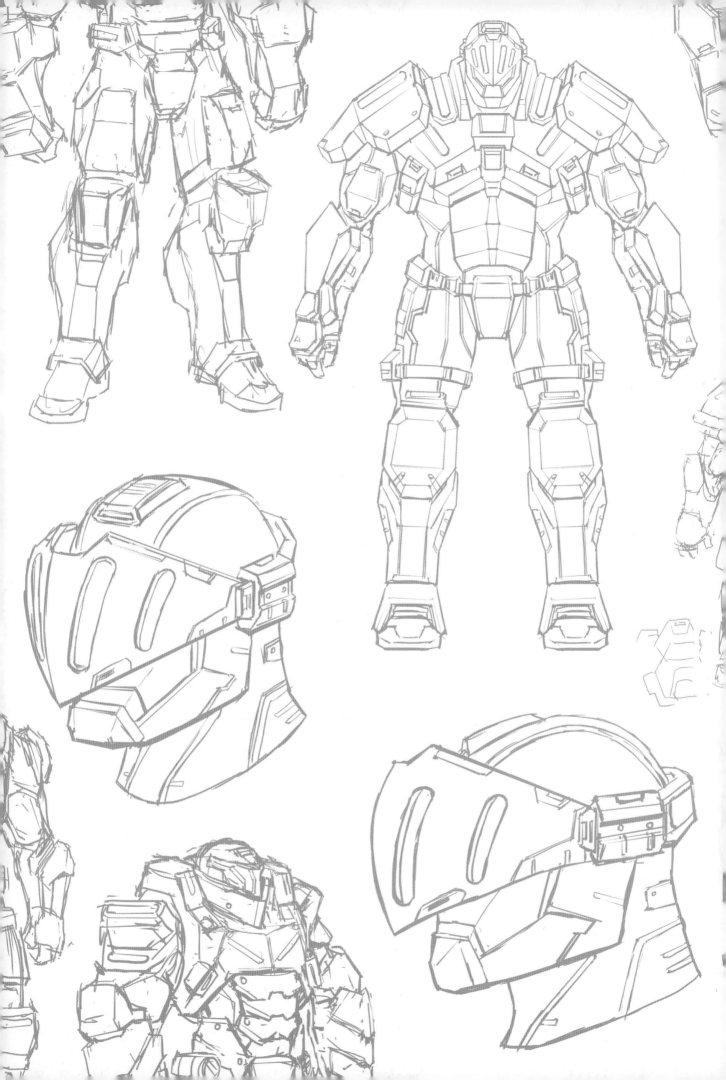

HYBRID

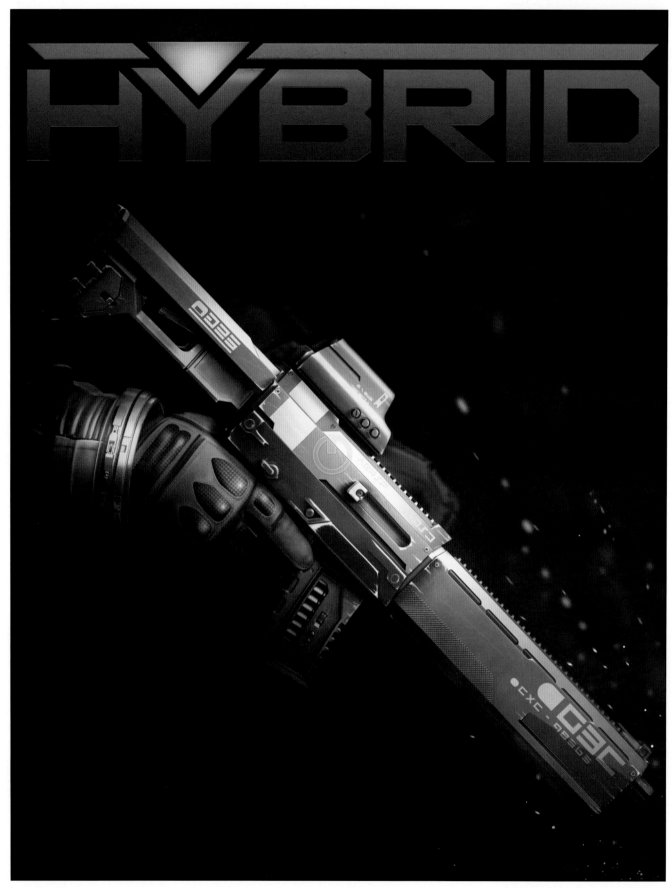

● HYBRID - KEY VISUAL

● PALADINS
● CHARACTER CONCEPTS

COMMENT

Hybrid was 5TH Cell's first 3D game, a competitive third person cover-based shooter. It was released on Xbox Live in 2011. *[Joe Tringali]*

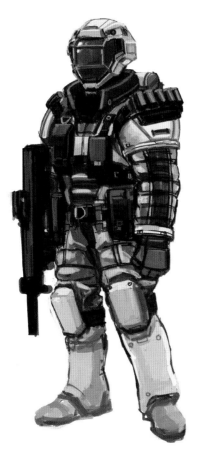
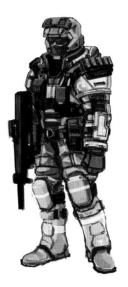
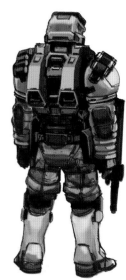
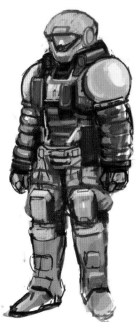
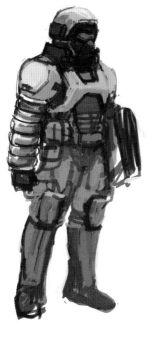
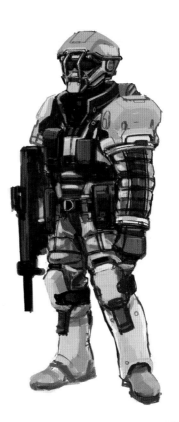
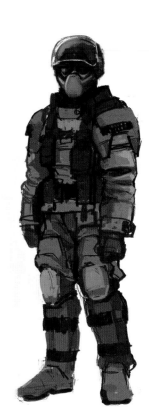

⬡ PALADINS
● HELMET CONCEPTS

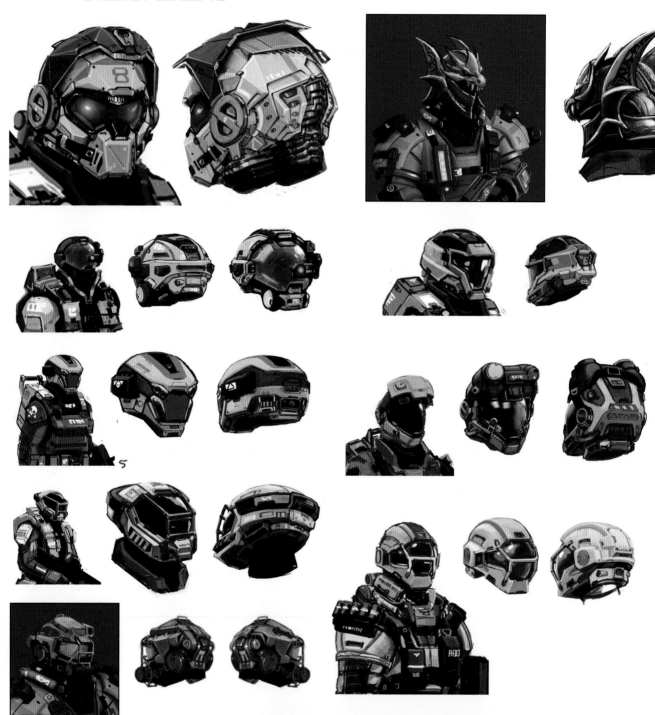

⬡ COMMENT

Helmets were a large part of a player's identity and a way of customizing their appearance. Hundreds of helmets were designed for both factions and were eventually narrowed down to a dozen or so used in the game. *[Scott Kikuka]*

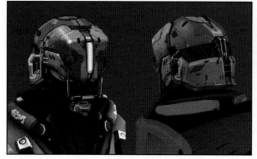

Loser

HELMET CONCEPTS

 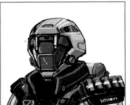 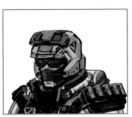 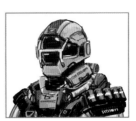 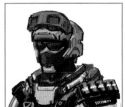

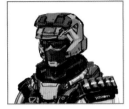 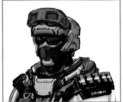 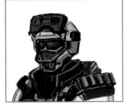 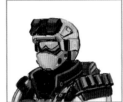 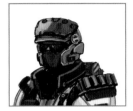

CHARACTER CONCEPTS

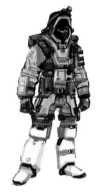 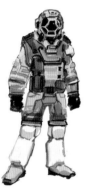 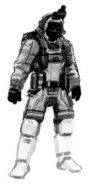 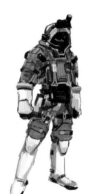 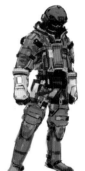 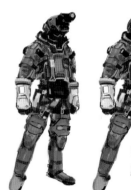

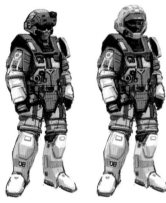 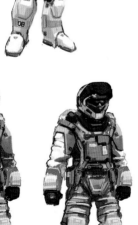 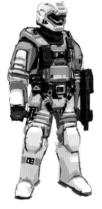 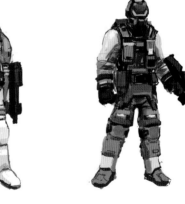

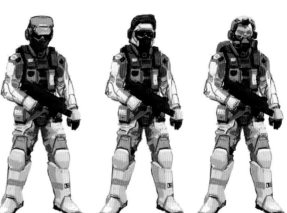

PALADINS
CHARACTER CONCEPTS

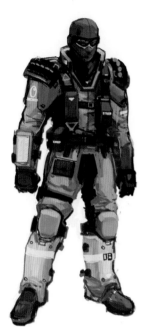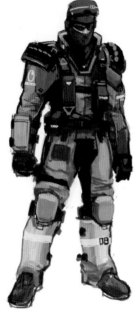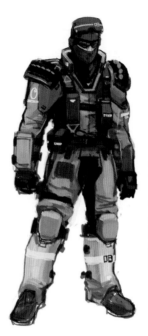

HEAD CONCEPTS

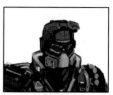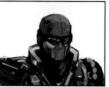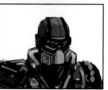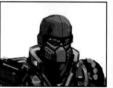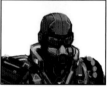

COMMENT

Color choice was heavily stressed in the designing of the characters. A lot of exploration was done with color palettes to improve visibility/readability during combat. We focused on trying to make the characters readable while they were far away behind cover. *[Scott Kikuka]*

HEAD CONCEPTS

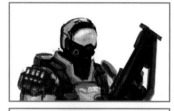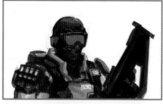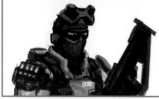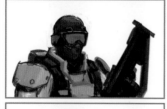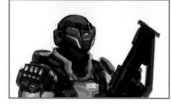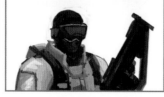

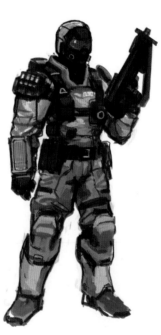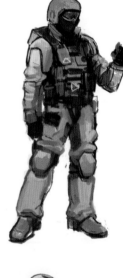

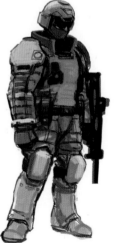

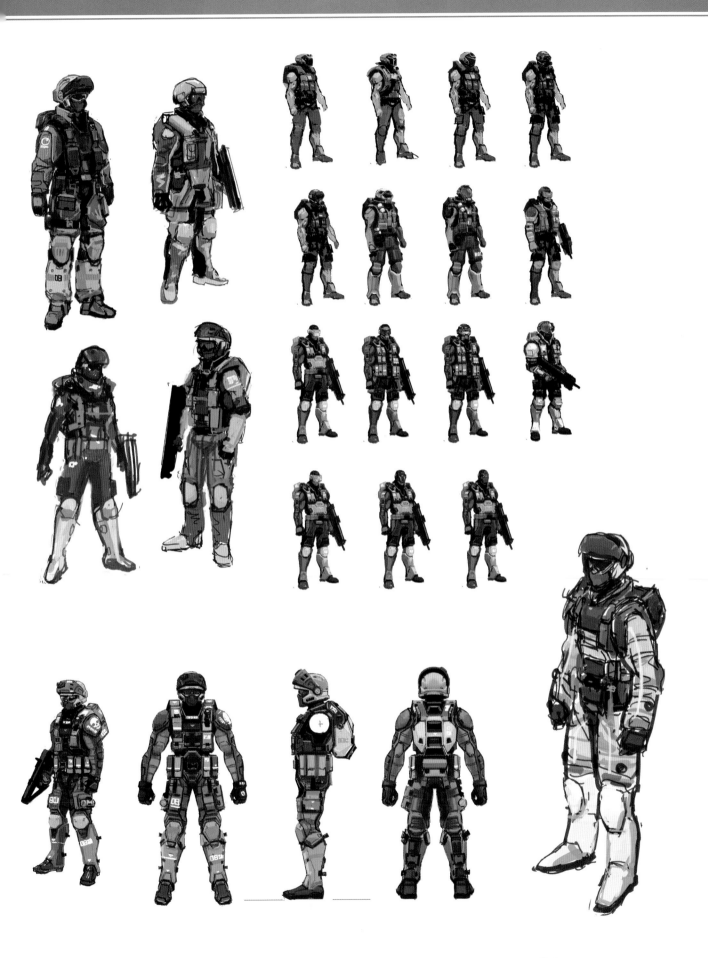

PALADINS
ROUGH SKETCHES

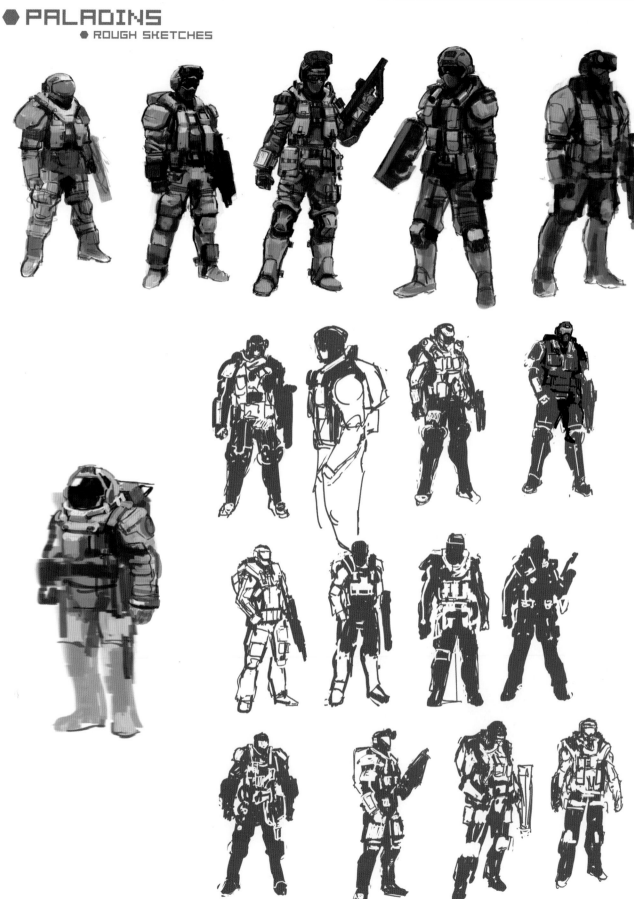

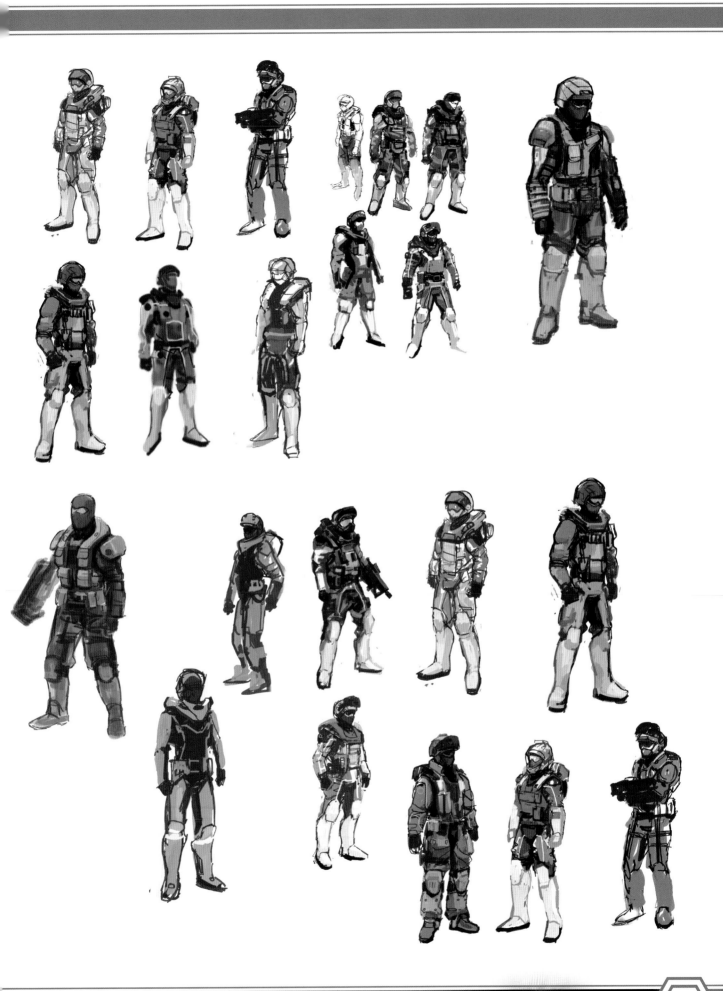

PALADINS
ROUGH SKETCHES

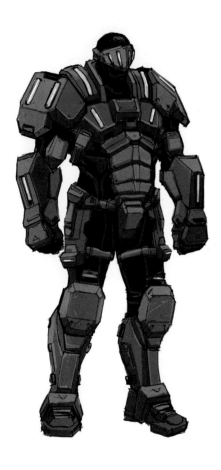

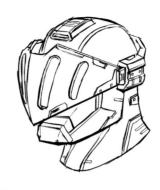

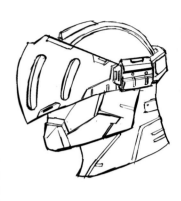

COMMENT

A very early Paladin design. You can see the idea of the old knight helmet design incorporated into the futuristic armor. This design was built and used for our announcement trailer at GDC. *[Tom Angus]*

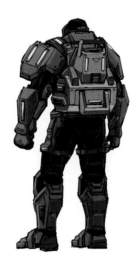

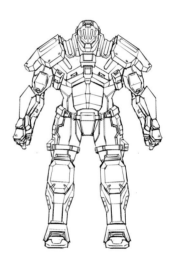

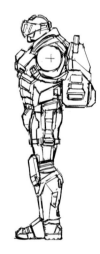

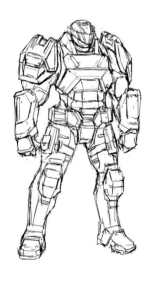

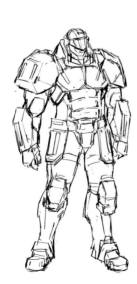

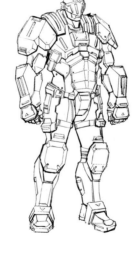

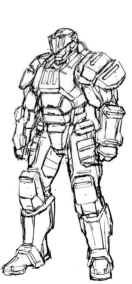

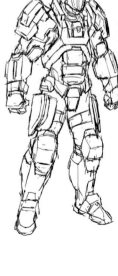

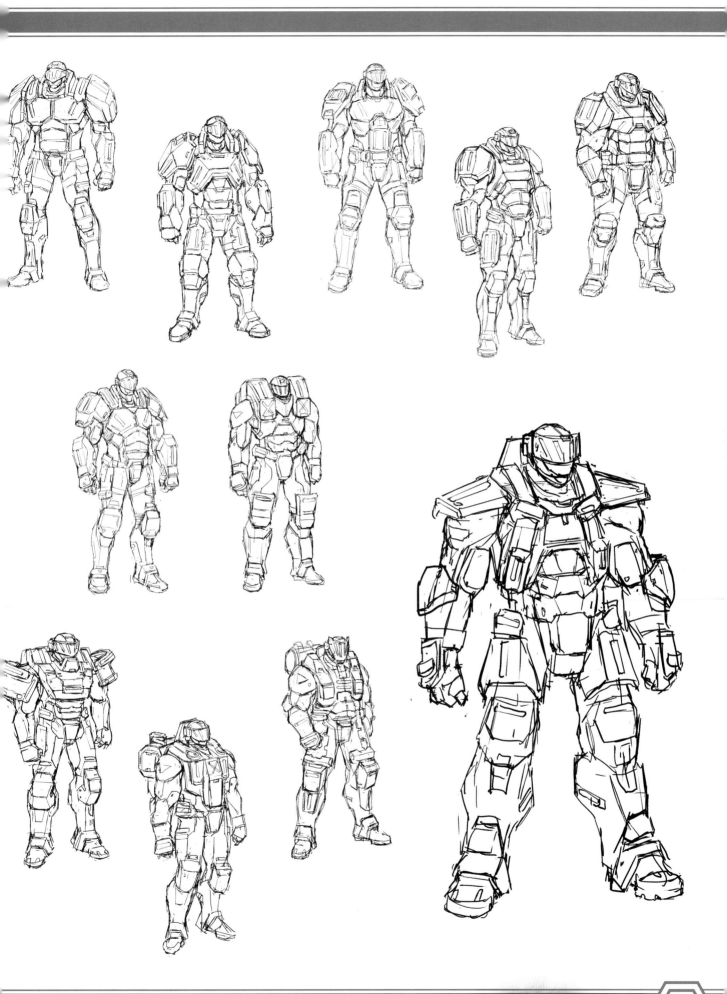

PALADINS
ROUGH SKETCHES

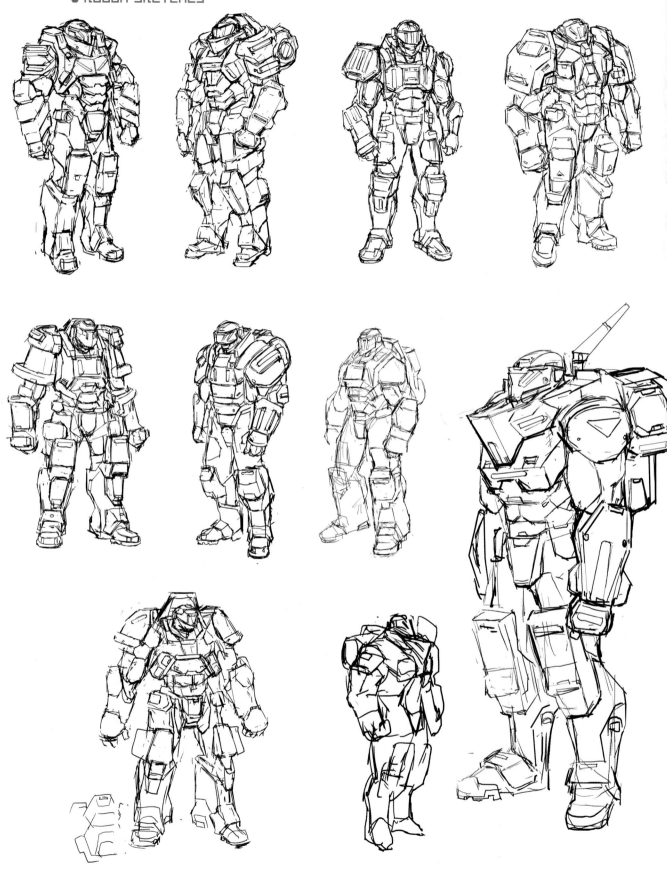

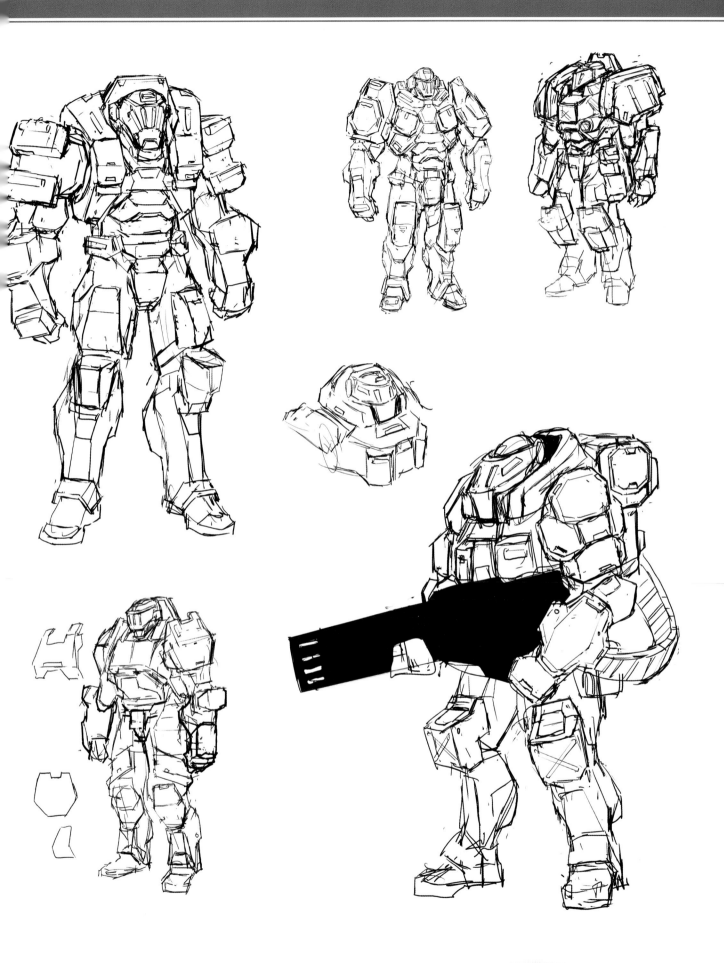

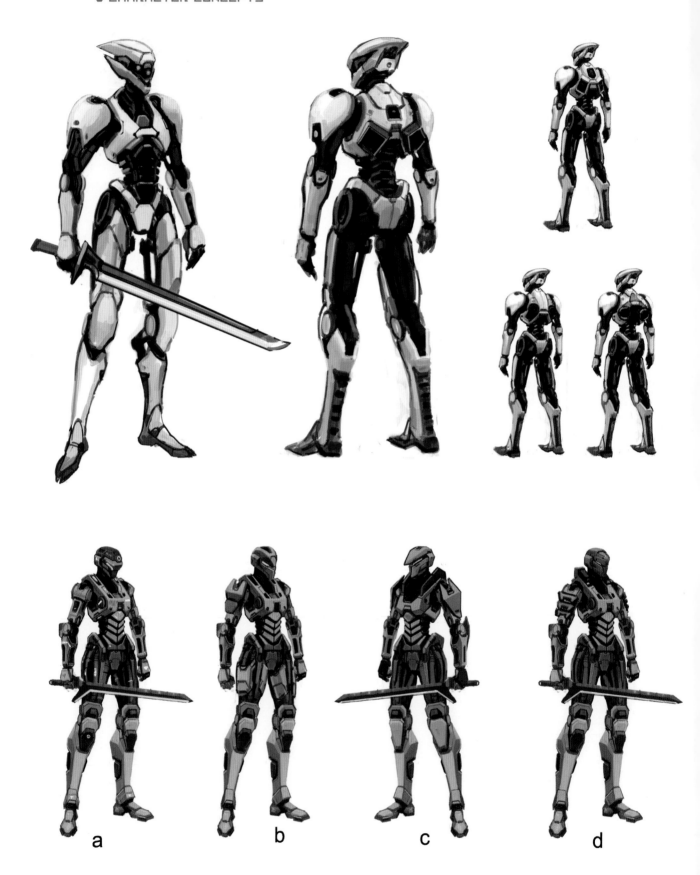

a

b

c

d

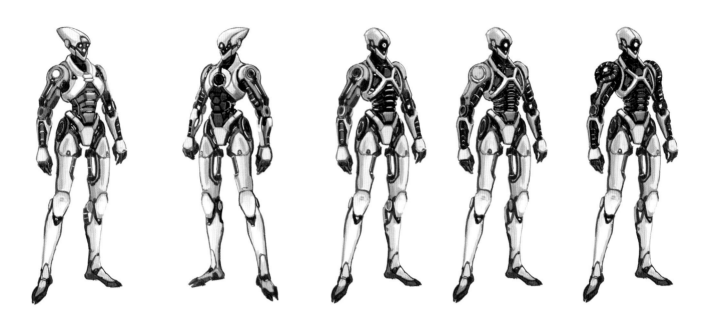

● HEAD CONCEPTS

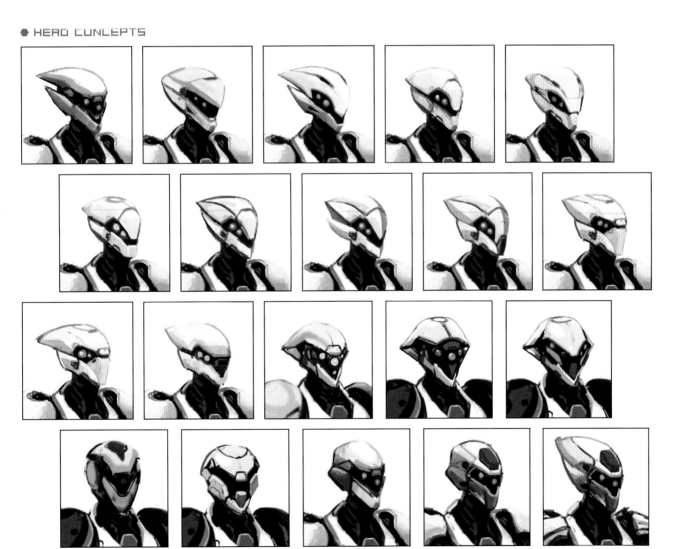

VARIANTS
HEAD CONCEPTS

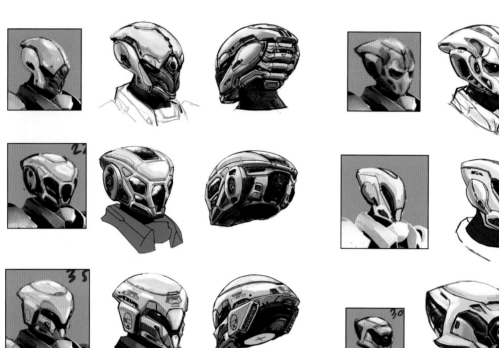
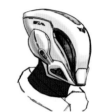
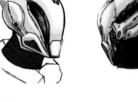

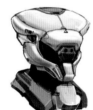
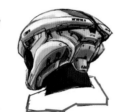
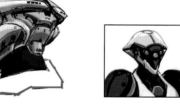
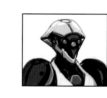
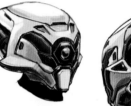
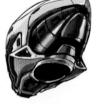
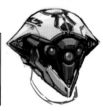
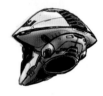

CHARACTER CONCEPTS

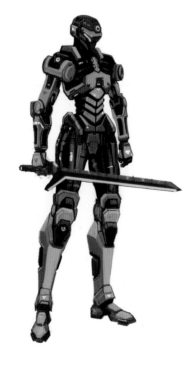
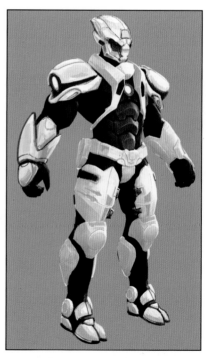

● VEHICLES

● CHOPPERS

COMMENT

This helicopter concept was used on the Defense Array map but you can only see it from the right side of the map. [Tom Angus]

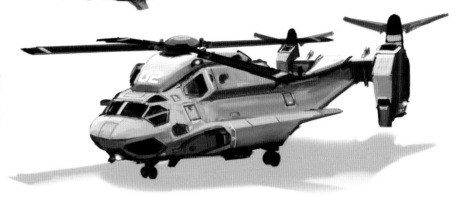

scaffolding connects to wall, or something....

COMMENT

The Variant Airship. These images were used a lot as inspiration throughout the development of Hybrid. The top image of the three shows the early idea for what became the Airship Drydock map. It then inspired an alternate interior version map where you are fighting inside the ship while it is flying a bombing run. [Tom Angus]

● HYBRID SHIP DESIGN

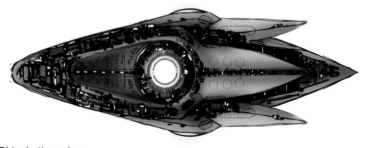

Hybrid Ship: bottom view

◆ VARIANTS
◆ TECH BUILDINGS

◆ SPECOPS

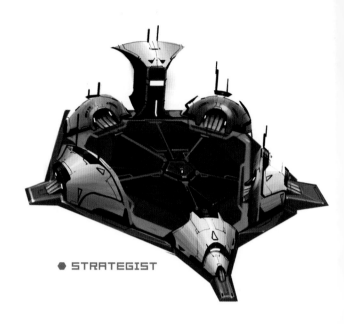

◆ STRATEGIST

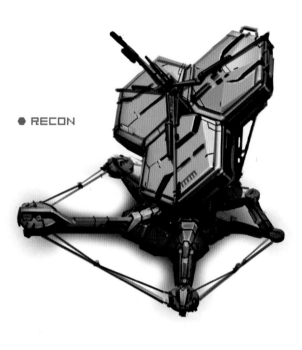

◆ RECON

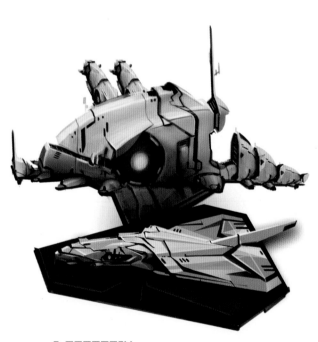

◆ ASSASSIN

◆ ARMORED

PALADINS
TECH BUILDINGS

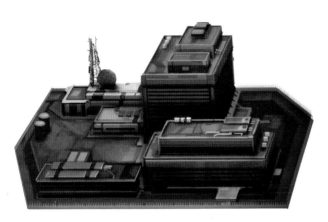

● SPECOPS

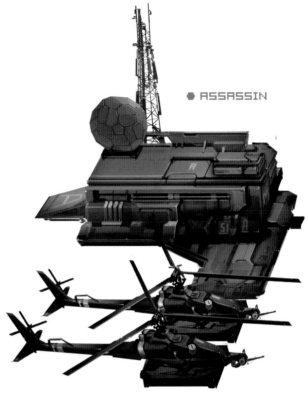

● ASSASSIN

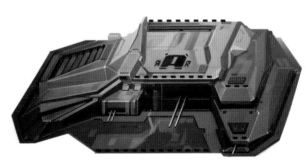

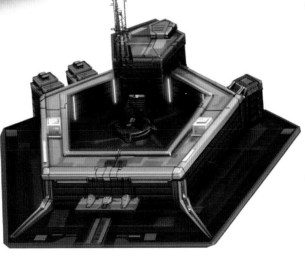

● RECON

● ARMORED

● STRATEGIST

◆ TECHNOLOGY

● TURRET CONCEPTS

◇ COMMENT

Turret concepts for the Depot map. The image on the right was the final concept and this prop was used in both the Depot and Defense Array maps. *[Tom Angus]*

ƐPOT:TURRET

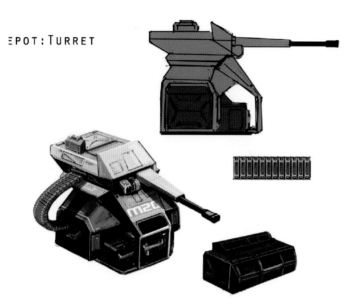

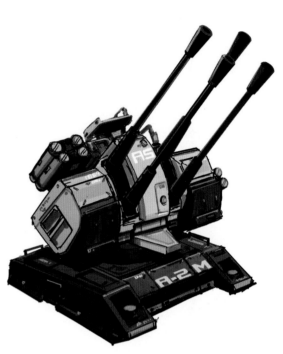

DEPOT TURRET SPAWN: TURRET REVISION

● BOMB CONCEPTS

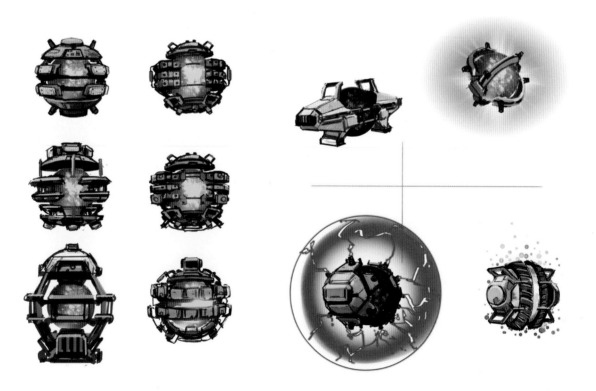

Trident Revisions

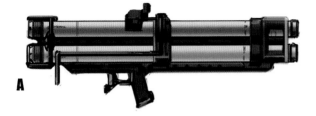

A

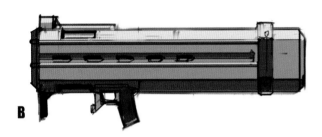

B

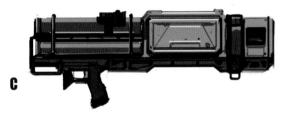

C

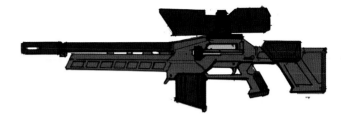

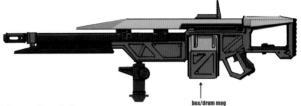

box/drum mag

Vulcan Revision

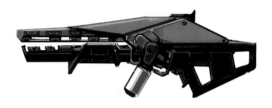

Plasma Flamethrower Revision

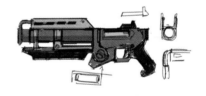

Revised Swarm Gun (uses big rifle template)

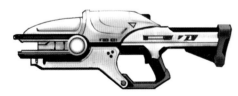

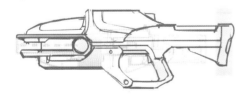

Double Barrel Shotgun

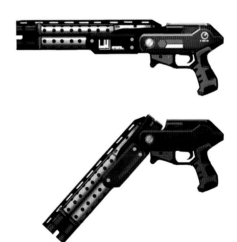

WEAPONS
ROUGH CONCEPTS

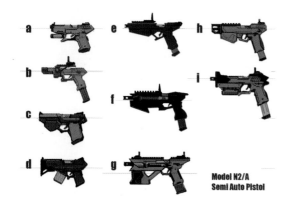

a e h
b f
c i
d g

Model N2/A Semi Auto Pistol

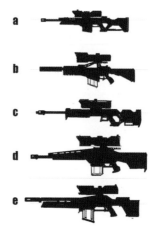

a f
b g
c h
d
e i

M9R Burst Sniper Rifle

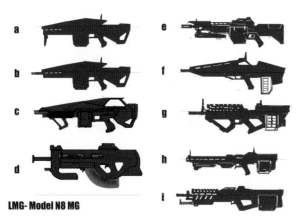

a e
b f
c g
d h
i

LMG- Model N8 MG

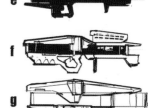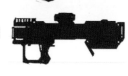

a e
b f
c g
d h

Model F2 Guided Missile System

a

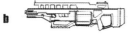
b

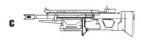
c

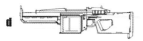
d

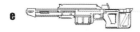
e

f

g

h

Fusion Bolt Rifle

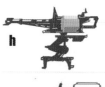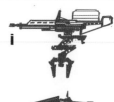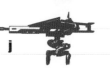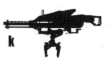

a d h
b e i
c f j
g k

Vulcan R 12MM

COMMENT

At one point in early game play design you could call in a drone that had a huge gun that could mount onto the cover models. *[Tom Angus]*

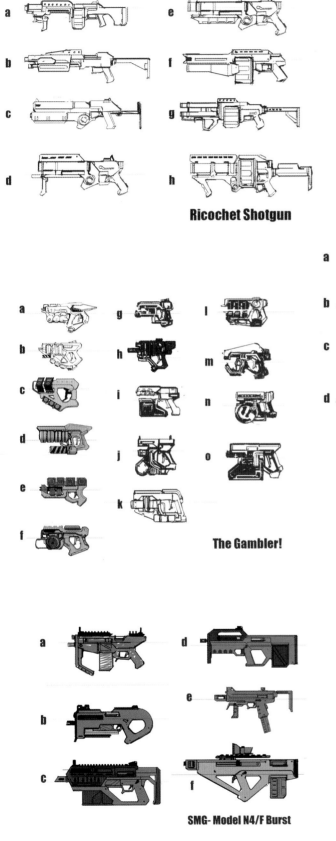

a

b

c

d

e

f

g

h

Ricochet Shotgun

a

b

c

d

e

f

g

h

i

j

k

l

Plasma Flame Thrower

a

b

c

d

e

f

g

h

i

j

k

l

MFM-244 Lance

a

b

c

d

e

f

g

h

i

j

k

l

m

n

o

The Gambler!

a

b

c

d

e

f

g

h

i

k

l

Charge Shotgun

a

b

c

d

e

f

SMG- Model N4/F Burst

⬡ ENVIRONMENTS
● CONCEPT ARTWORK

● STORY INTRODUCTION CONCEPT

⬡ **COMMENT**

At an early stage of the project we decided to adjust the look of our game and to aim for 60 FPS, up from 30 FPS. This is a paint over of our Depot map and this is very close to what actually shipped. We spent about six months on art development and gameplay on this one map trying to get both just right. *[Tom Angus]*

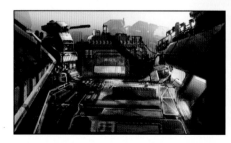

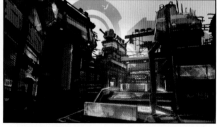

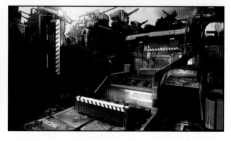

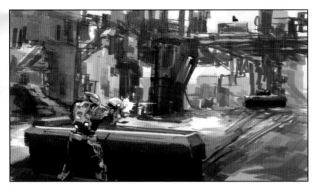

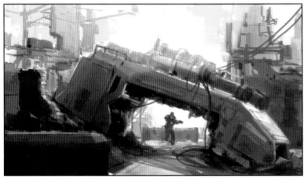

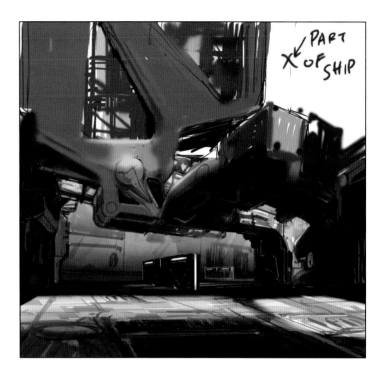

PART
OF SHIP

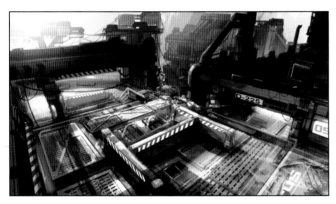

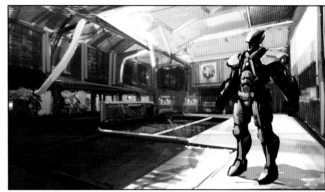

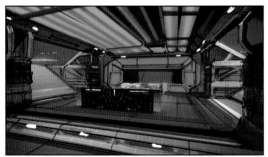

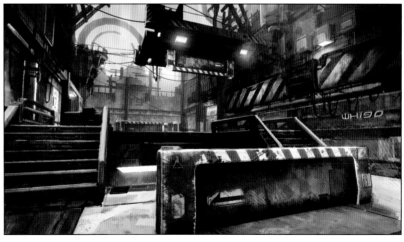

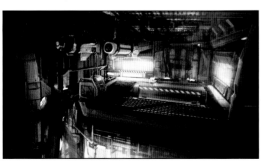

COMMENT

During development, we experimented with different styles for the environments. This concept uses a painted brush stroke look. [Tom Angus]

● ENVIRONMENTS
● CONCEPT ARTWORK

COMMENT

We wanted to design a ship dry dock type map that was human tech with Variant tech bolted on.
[Tom Angus]

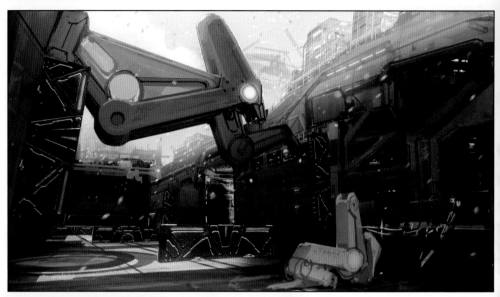

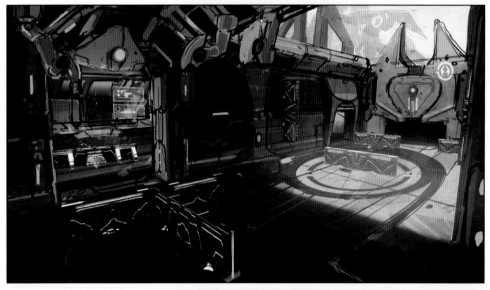

COMMENT

This was the first interior/exterior map that we worked on. In early gameplay the drones that you could call in were dropped from the sky. This made the interior maps challenging as we had to have an open area above each cover point. [Tom Angus]

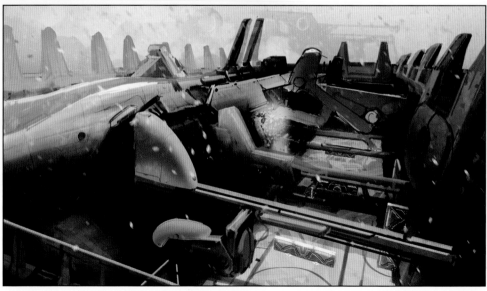

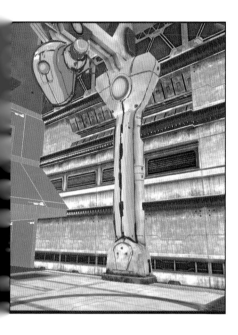

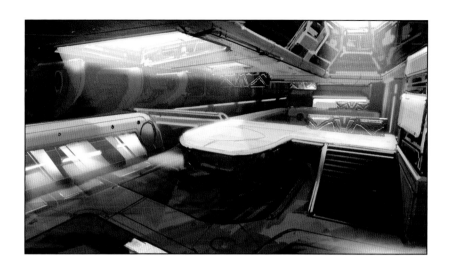

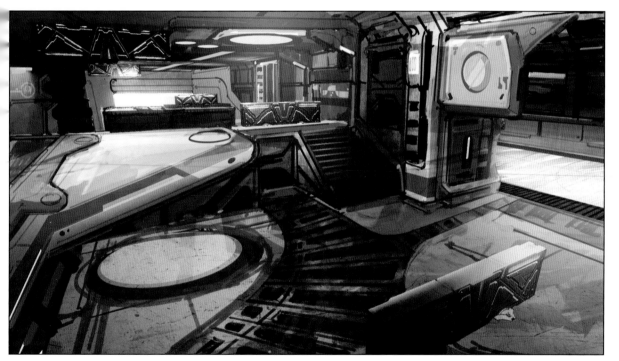

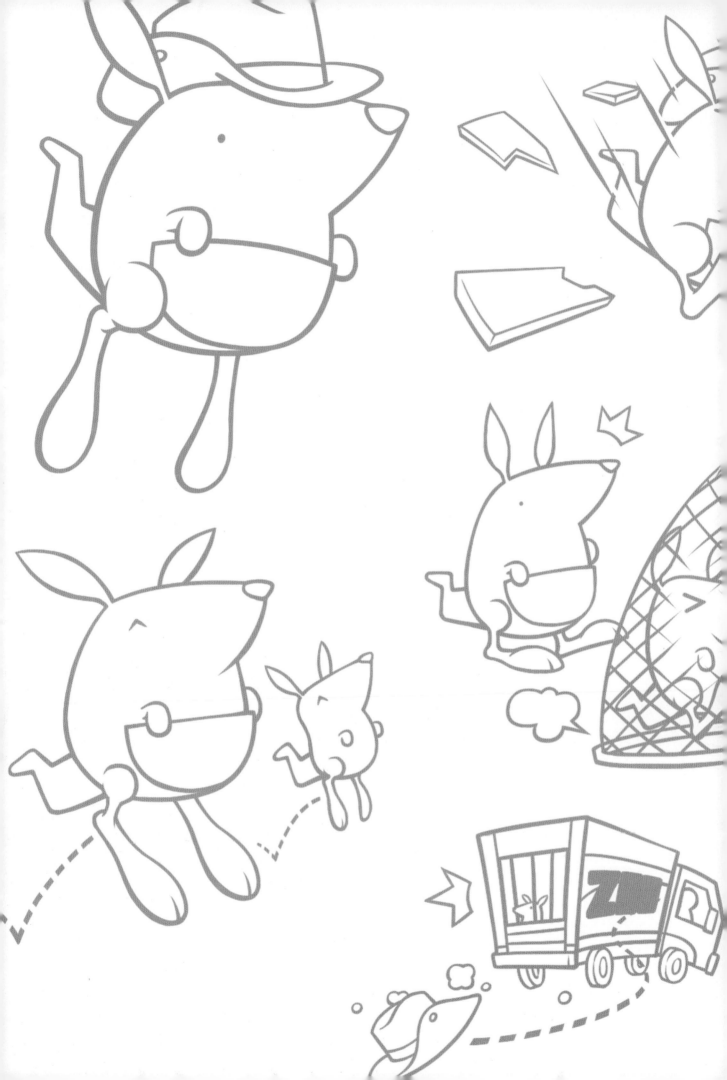

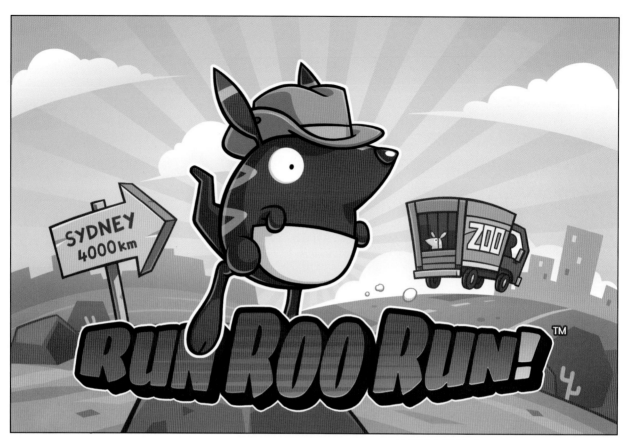

● RUN ROO RUN - TITLE SCREEN

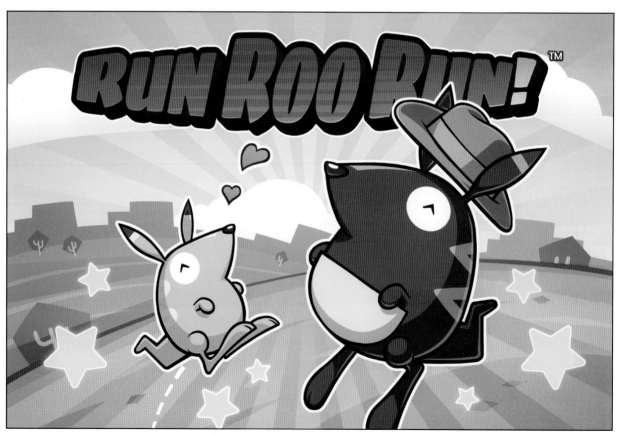

● RUN ROO RUN - KEY VISUALS

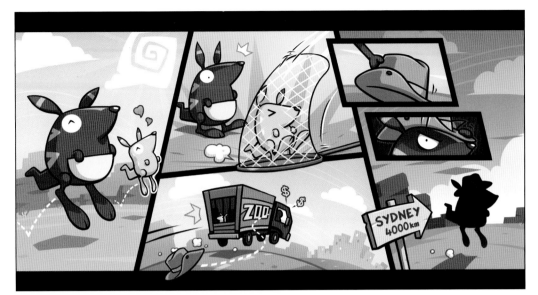

● INTRO COMIC

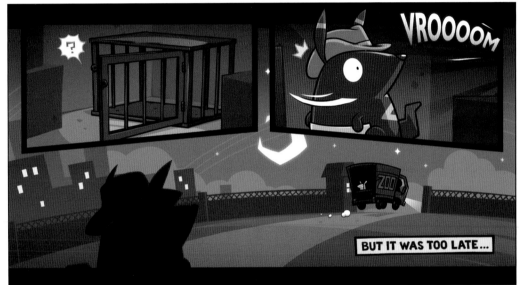

● ENDING COMIC 1

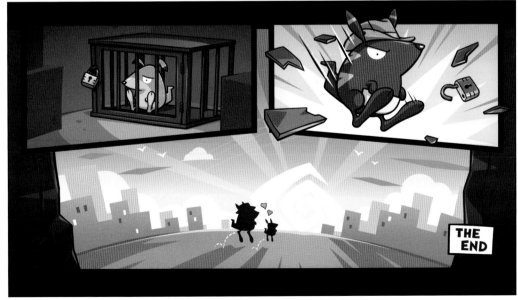

● ENDING COMIC 2

COMMENT

Australia is a big country. Roo had a long way to go to rescue her joey. [Joe Tringali]

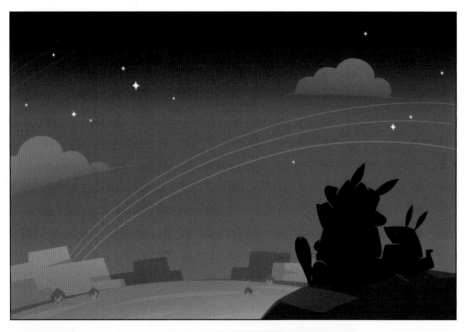

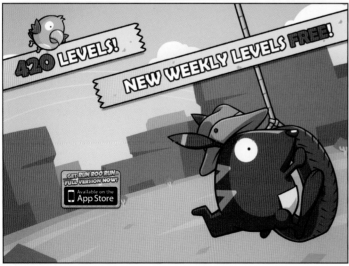

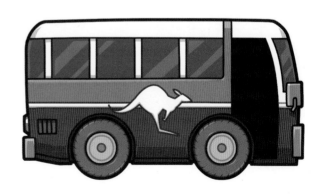

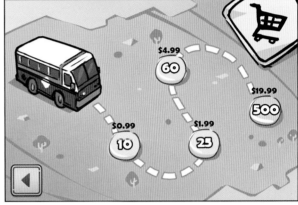

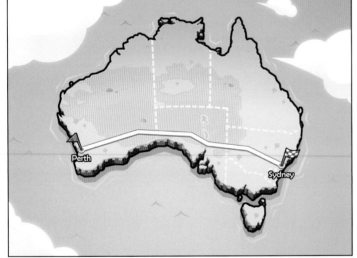

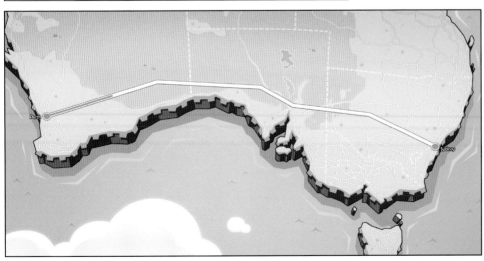

● WORLD MAP

CATCH A RIDE!

TUNNEL TELEPORTER!

JUMP OFF LOW!

AUTOMATIC SPRING!

WAIT FOR THE SPIKE TO LOWER!

SLOW MOTION HELP

USE THE ROUNDABOUT!

CAREFUL, IT CRUMBLES!

OIL SLICK, VERY FAST!

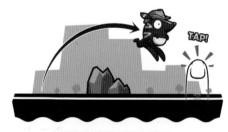

TAP TO START, TAP TO JUMP!

JUMP FROM HOOK TO HOOK

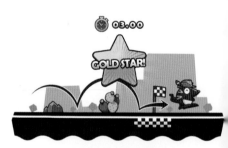

LOW TIME = GOLD STAR!

ROO IS INVISIBLE!

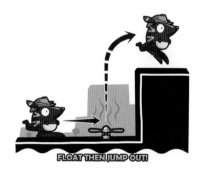

FLOAT THEN JUMP OUT!

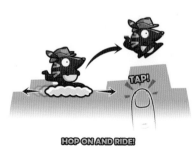

HOP ON AND RIDE!

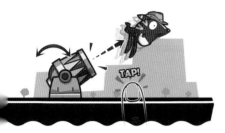

ANGLE THEN SHOOT!

TURN ON THE SWITCH!

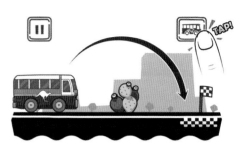

INSTANTLY BEAT LEVEL

HIT THE BIRD'S HEAD!

JUMP, ROLL AND FLOAT!

CHANGE THE GRAVITY!

ALWAYS DOUBLE JUMP!

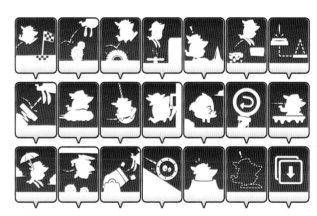

● LEVEL SELECT ICONS

● CHARACTER SPRITE SHEET

● ROUGH SKETCHES

● IN-GAME OBJECT CONCEPTS

SHEEP TIRE CLOUD

CACTUS DEAD BRANCH ROCK FISH BIRD

will be hard to make them more jagged because they need to conform closely to collision box

WATER SAND

EXPLODING BARREL EXPLODING CRATE EXPLOSION

Ⓐ DETAILED Ⓑ SIMPLE

which one to go for?

BREAKS

using Brown Crate instead of wooden planks might be better for this, as the cubic shape looks less hostile than planks poking out from the ground?

WOOD BROWN CRATE

OFF → ON

SWITCH

SPIKE STRIP MISSING FLOOR

size to be determined later

FALSE BRIDGE

● ROO CHARACTER CONCEPTS

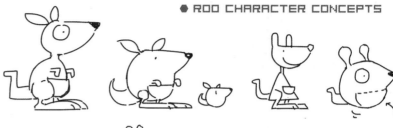

POUC

JUMP

Color & Markings

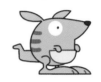 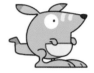

Accessories

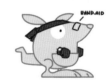 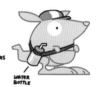

BAND-AID NO ARMS WATER BOTTLE

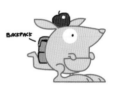 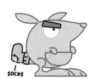 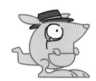

BACKPACK SOCKS

⬡ COMMENT

We had plans to add customized costumes for Roo, but that feature didn't make it into the game. *[Chern Fai]*

● ICON CONCEPTS

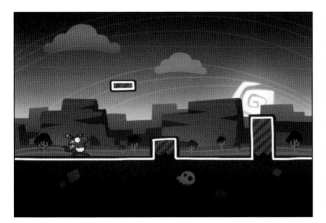
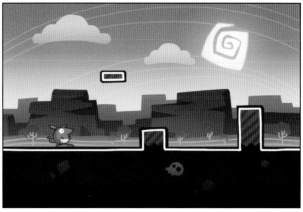

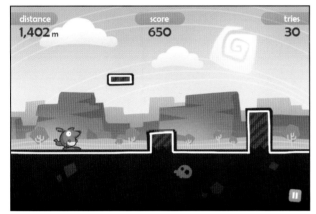
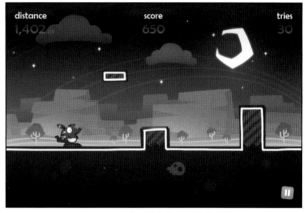

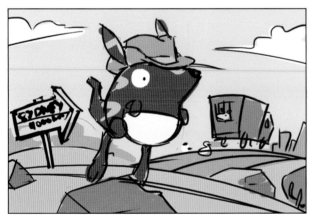
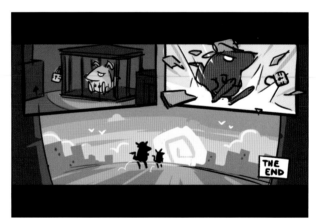

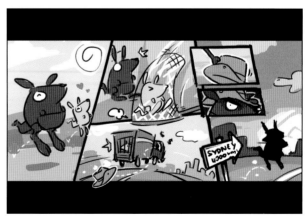

● ROUGH LAYOUTS

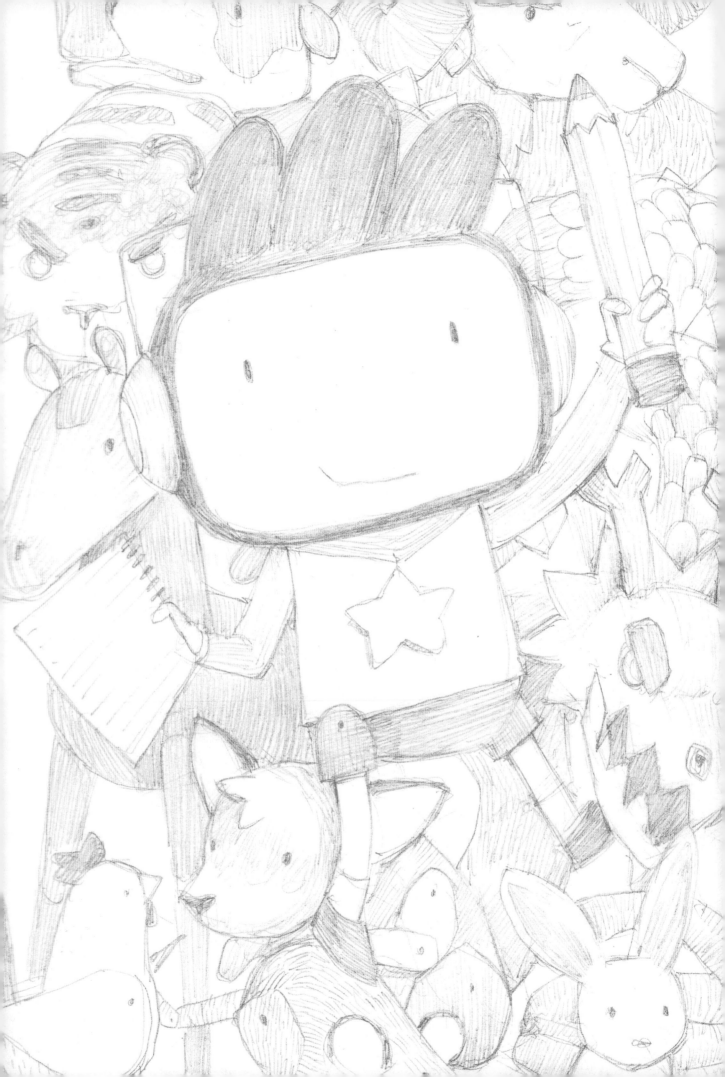

EDISON YAN
Sketchbook

● EDISON YAN SKETCHBOOK
● MINI POCCHA

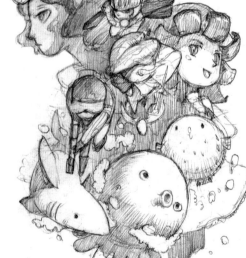

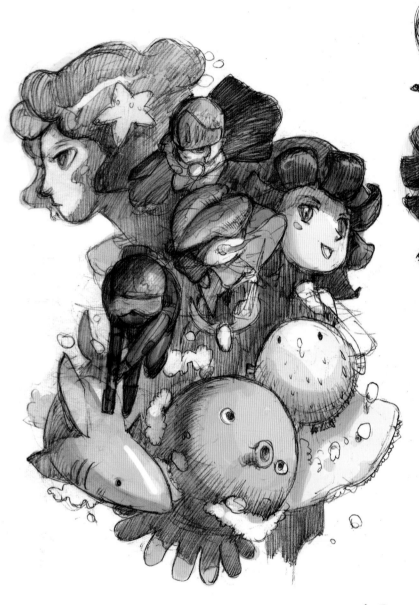

~ MINI POCCHA ~

~ MINI POCCHA ~

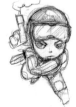 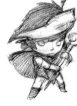 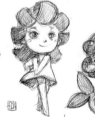

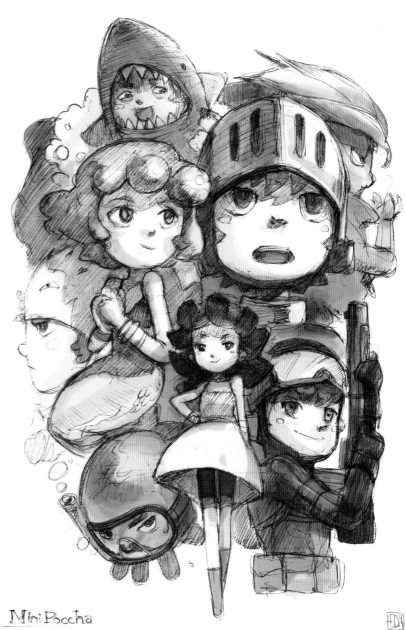

Mini Poccha

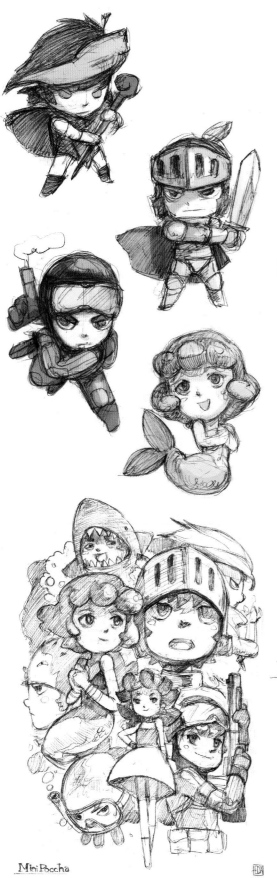

Mini Poccha

COMMENT

5TH Cell's first three games *Siege*, *Seal Team 6* and *Mini Poccha* were released in 2004. *[Joe Tringali]*

◆EDISON YAN SKETCHBOOK

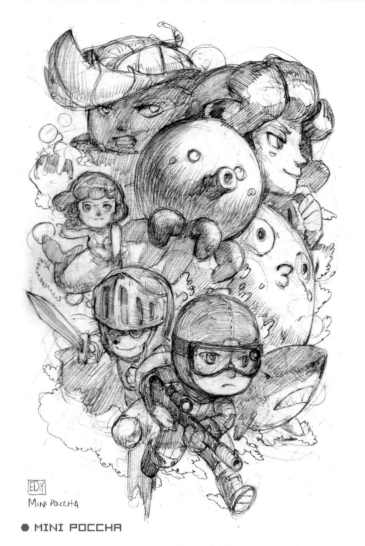

● MINI POCCHA

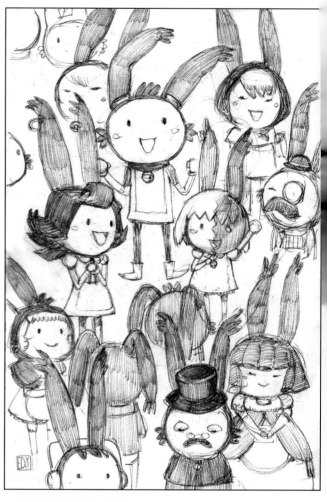

● DRAWN TO LIFE

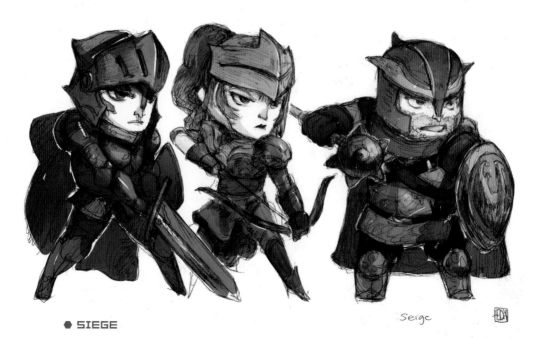

● SIEGE

Serge

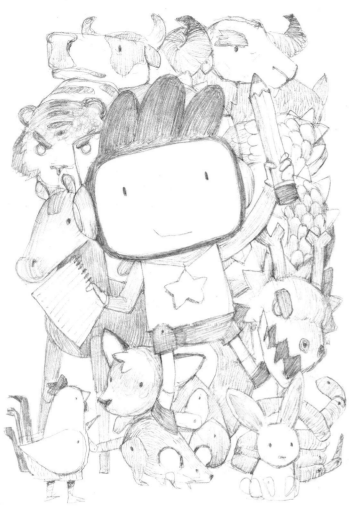

● SCRIBBLENAUTS

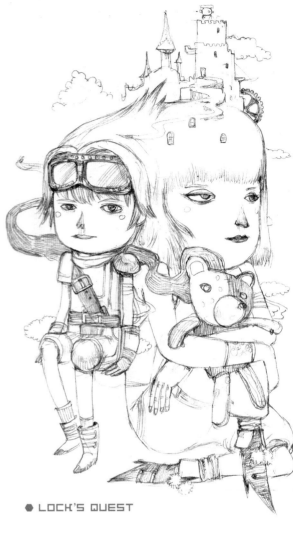

● LOCK'S QUEST

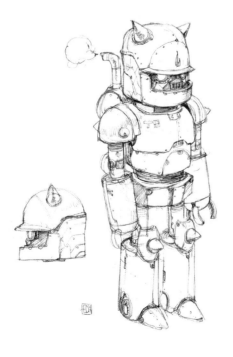

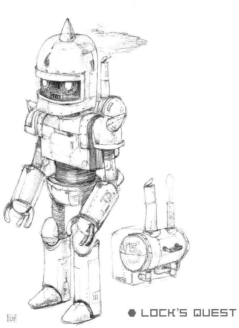

● LOCK'S QUEST

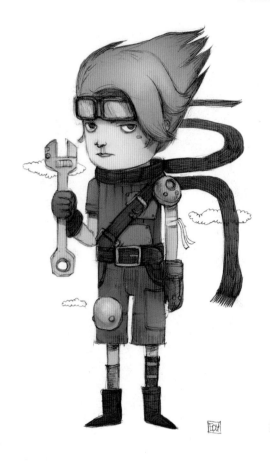
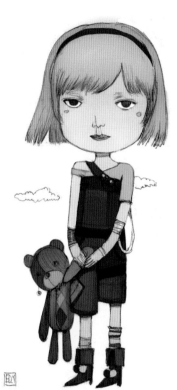
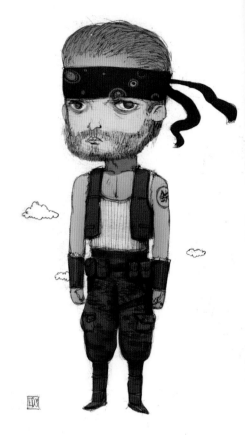

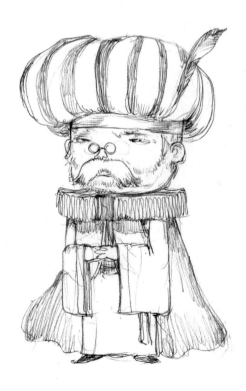
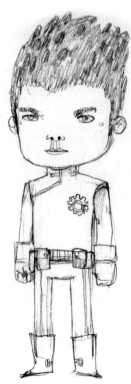
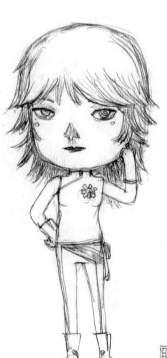

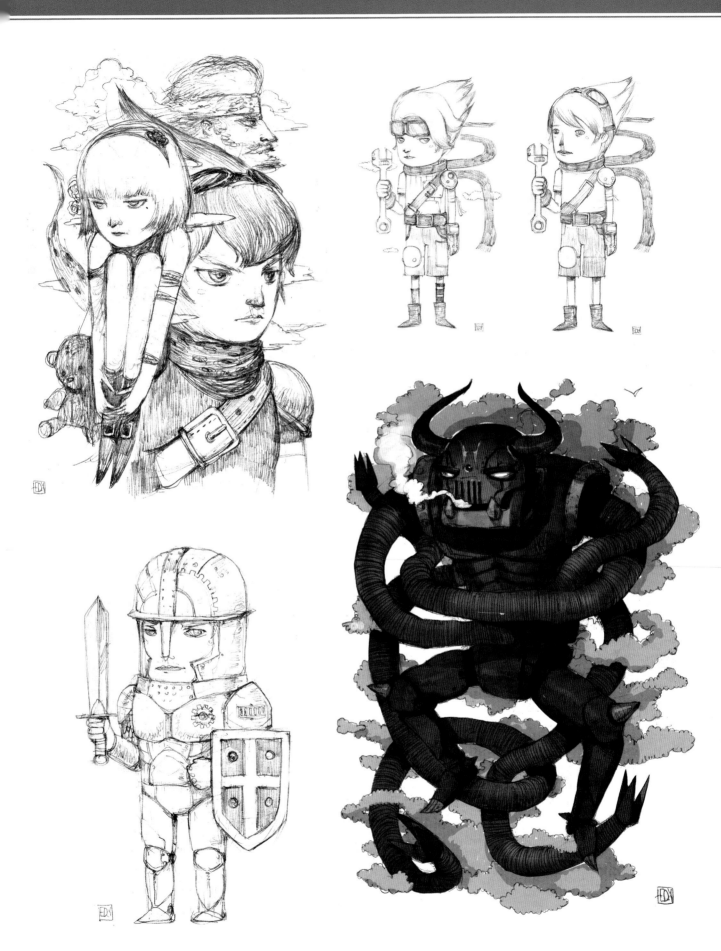

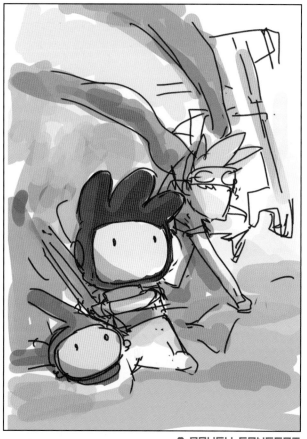

◆ ROUGH CONCEPT

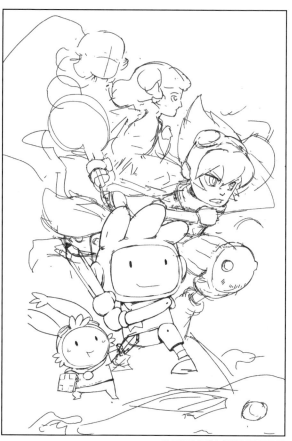

◆ ROUGH CONCEPT

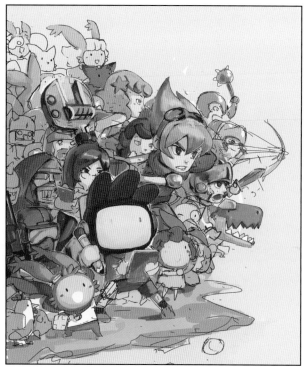

◆ PROGRESS 1

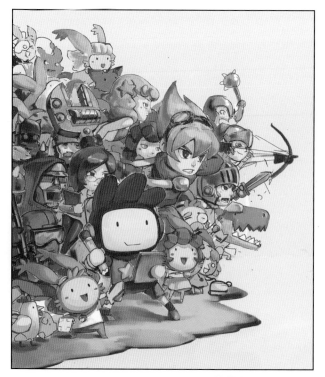

◆ PROGRESS 2

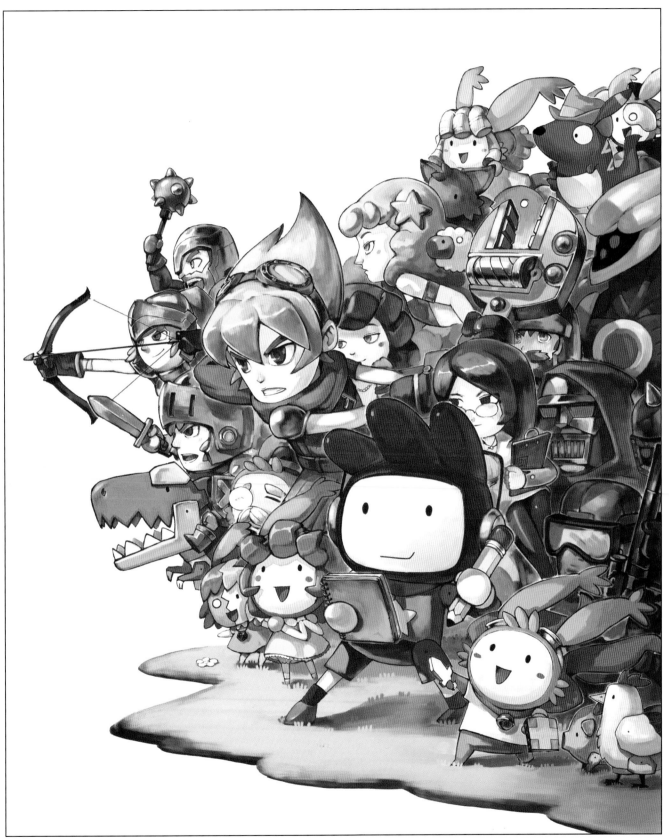

● FINAL COVER ART

5TH CELL ORIGINAL GAMES

● D.N.A.

CATEGORY: Action Puzzle
PLAYERS: Single
PLATFORM: PC
PUBLISHER: Merscom
RELEASE DATE: 2006

This addictive puzzle game offers a completely new spin on the action puzzle genre! Play as Rose, a Genetic Specialist who must combine proteins and solve a unique medical mystery!

● SEAL TEAM 6

CATEGORY: Action / Stealth
PLAYERS: Single
PLATFORM: Mobile
PUBLISHER: THQ Wireless
RELEASE DATE: Nov. 2004

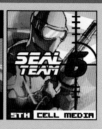

SEAL Team 6 gives the player control over an elite squad of SEAL operatives who must infiltrate an office building occupied by an extremist militant group known as Red Cell, and eliminate them by any means necessary.

● SIEGE

CATEGORY: Action / Castle Defense
PLAYERS: Single
PLATFORM: Mobile
PUBLISHER: THQ Wireless
RELEASE DATE: 2004

The user must defend their castle, with the objective of stopping an invasion from an endless horde of enemies. The player must prevent the advancing enemy using his skill, wit and allied forces at his disposal.

● MINI POCCHA

CATEGORY: Puzzle / Battle
PLAYERS: Single
PLATFORM: Mobile
PUBLISHER: THQ Wireless
RELEASE DATE: 2004

Players control blocks of water filled with different colors and attempt to match color patterns to unleash combos against their opponent. Mini Poccha offers multiple game modes and endless replayability.

● RUN ROO RUN

CATEGORY: Platformer
PLAYERS: Single
PLATFORM: iOS
PUBLISHER: 5TH Cell
RELEASE DATE: 2012

Hop, skip, and jump your way across unique obstacles in the Australian outback! Run Roo Run is a micro-platformer featuring single screen levels and easy to learn, one-touch gameplay. Play for a few minutes, or a few hours; your journey to Sydney always picks up where you left off!

● DRAWN TO LIFE

CATEGORY: Adventure
PLAYERS: Single
 (WiFi Enabled)
PLATFORM: Nintendo DS
PUBLISHER: THQ
RELEASE DATE: SEP 2007

 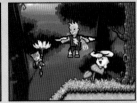

Drawn to Life takes players to the next level of interaction and creativity on the Nintendo DS. Your exact drawings populate the game, and no tedious animating or image manipulation is necessary. In other words, your drawing comes to life!

● DRAWN TO LIFE: THE NEXT CHAPTER

CATEGORY: Adventure
PLAYERS: Single
 (WiFi Enabled)
PLATFORM: Nintendo DS
PUBLISHER: THQ
RELEASE DATE: Oct. 2009

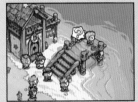 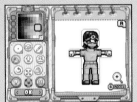

Continue the adventure in Drawn to Life: The Next Chapter, for the Nintendo DS! Follow Jowee, Mari and Heather through their greatest adventure yet, with an improved Draw Mode, in-level Action Drawing, and an engaging storyline.!

● LOCK'S QUEST

CATEGORY: Action Strategy
PLAYERS: Single
 (with Multi-card play)
PLATFORM: Nintendo DS
PUBLISHER: THQ
RELEASE DATE: SEP 2008

 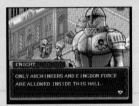
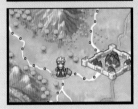 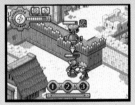

Lock, an aspiring Archineer embarks upon a quest to stop an invading Clockwork army led by Lord Agony. Build defenses or Battle with Lock using just the stylus;, unleashing devastating special and super attacks. Adventure through a detailed story, filled with unique characters and frentic gameplay. You have little more than a wrench, your wit and a heart to protect those you care about most.

● HYBRID

CATEGORY: 3rd Person Shooter
PLAYERS: Multiplayer
PLATFORM: Xbox 360
PUBLISHER: Microsoft
RELEASE DATE: 2012

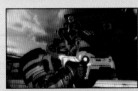

A mysterious explosion obliterates Australia and an entity from unknown origins has appeared on the planet. Chaos ensues and world war breaks out between the Paladins and the Variants. Join a worldwide campaign to fight for a mystifying power source that can restore order or dominate mankind; the choice is yours.

5TH CELL ORIGINAL GAMES

● SCRIBBLENAUTS

CATEGORY: Emergent
PLAYERS: Single
(WiFi Enabled)
PLATFORM: Nintendo DS
PUBLISHER: WB Games
RELEASE DATE: SEP 2009

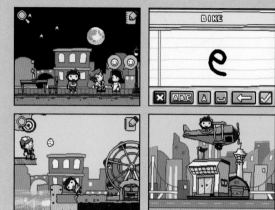

5TH Cell invites players from all backgrounds to use their imagination and wit in this groundbreaking, original IP for the Nintendo DS!

The premise is simple: The player uses the touch-screen to help their character, Maxwell, acquire the star in each level by solving a series of puzzles. The twist is, in order to solve each puzzle the players use the notepad to write down objects that are used to reach the goal.

This game is all about experimentation, imagination and endless replay value. Think of anything, write it down, and watch it come alive! Write Anything, Solve Everything!

● SUPER SCRIBBLENAUTS

CATEGORY: Emergent
PLAYERS: Single
(WiFi Enabled)
PLATFORM: Nintendo DS
PUBLISHER: WB Games
RELEASE DATE: Oct. 2010

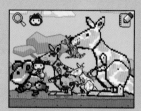

The action continues in this sequel to the award-winning puzzle game, Scribblenauts. Using the touch-screen, help Maxwell collect the "starite" in each level by writing any object you can think of and bringing it to life.

● SCRIBBLENAUTS REMIX

CATEGORY: Emergent
PLAYERS: Single
PLATFORM: iOS, Android
PUBLISHER: WB Games
RELEASE DATE: Oct. 2011

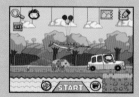

Let your imagination run wild in this groundbreaking puzzle game. Summon to life a 'colossal winged car' or a 'shy frost-breathing robotic hippopotamus'! If you can think it, you can create it. It's the perfect game for the casual player looking for fun and extensive replay with unlimited solutions and different outcomes.

● SCRIBBLENAUTS UNLIMITED

CATEGORY: Emergent
PLAYERS: Single/Multiplayer
PLATFORM: 3DS, WiiU, PC
PUBLISHER: WB Games
RELEASE DATE: NOV 2012

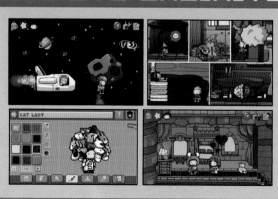

Venture into a wide-open world where the most powerful tool is your imagination. Help Maxwell solve robust puzzles in seamless, free-roaming levels by summoning any object you can think of. Create your own original objects, assign unique properties, and share them with friends online to be used in game or further modified as they like! And for the first time, learn the backstory about Maxwell's parents, 41 siblings (including his twin sister Lily), and how he got his magical notepad.

◆ UNRELEASED GAME CONCEPTS

As of 2014, 5TH Cell has shipped 21 titles, and there are 23 unreleased concepts/titles we worked on to various stages of completion. These are a few of them. *[Joe Tringali]*

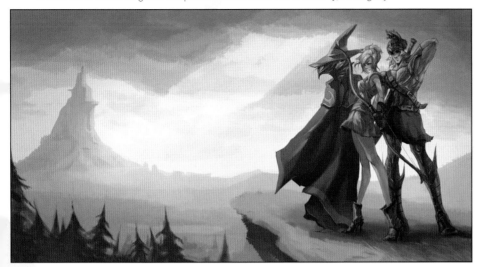

● MOBILE PHONE MMORPG

⬡ COMMENT

Back in 2005 we developed a mobile phone MMORPG. We had it running, but unfortunately couldn't find funding to complete it. *[Joe Tringali]*

● NINTENDO WII RACER CONCEPT

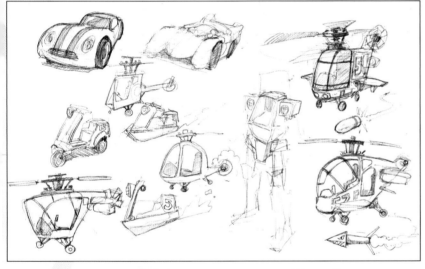

● NINTENDO WII DUNGEON CRAWLER CONCEPT

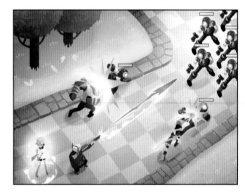

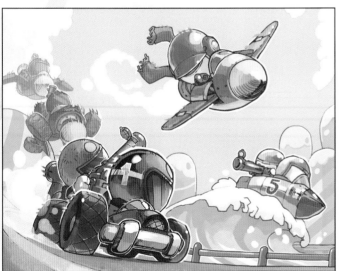

⬡ COMMENT

This was a Nintendo Wii Racer concept. The player would transform into different vehicles depending on the obstacles. *[Joe Tringali]*

THE ART OF
5THCELL™

BOOK PRODUCTION

PROJECT EDITOR
Matt Moylan

SPECIAL THANKS
Edison Yan
Joseph M. Tringali
Ari Bilow
Chern Fai
Scott Kikuta
Tom Angus
Akio Segawa

UDON STAFF

CHIEF OF OPERATIONS
Erik Ko

MANAGING EDITOR
Matt Moylan

DIRECTOR OF MARKETING
Christopher Butcher

MARKETING MANAGER
Stacy King

ASSOCIATE EDITOR
Ash Paulsen

PRODUCTION MANAGER
Janice Leung

EDITORIAL ASSISTANCE
Michelle Lee

5TH CELL OWNERS

CEO/CREATIVE DIRECTOR
Jeremiah Slaczka

CHIEF OPERATING OFFICER
Joseph M. Tringali

TECHNICAL DIRECTOR
Marius Fahlbusch

Published by UDON Entertainment Corp.
118 Tower Hill Road, C1, PO Box 20008, Richmond Hill, Ontario, L4K 0K0 CANADA.

www.UDONentertainment.com

First Printing: October 2014
ISBN-13: 978-1-927925-24-9
ISBN-10: 1-927925-24-X

Printed in China